IMAGES
of America

DUNKIRK

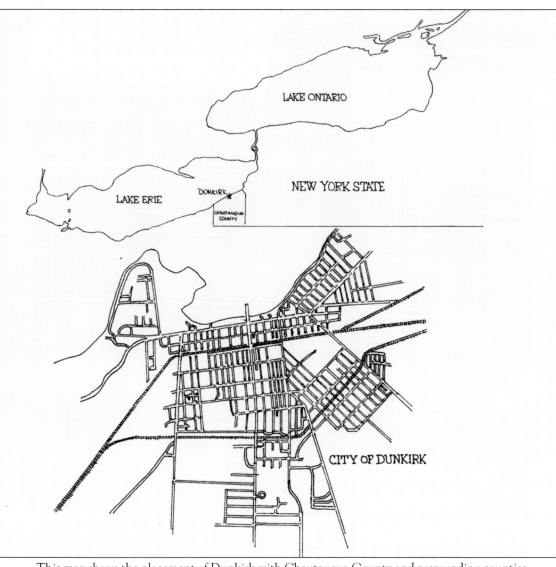

This map shows the placement of Dunkirk with Chautauqua County and surrounding counties. (Rodney Geiben.)

On the cover: Dunkirk's diversity of manufacturing facilities included a car-manufacturing plant. The Chautauqua Motor Company built this chain-driven truck in 1910. (Historical Society of Dunkirk.)

IMAGES
of America

DUNKIRK

Diane Andrasik

ARCADIA
PUBLISHING

Published by Arcadia Publishing
Charleston, South Carolina

Printed in the United States of America

Library of Congress Catalog Card Number: 2007941599

For all general information contact Arcadia Publishing at:
Telephone 843-853-2070
Fax 843-853-0044
E-mail sales@arcadiapublishing.com
For customer service and orders:
Toll-Free 1-888-313-2665

Visit us on the Internet at www.arcadiapublishing.com

*To my parents, the late Joseph and Genevieve Andrasik, my brother
Joseph and sister Mary Ann, all Dunkirkers at heart*

CONTENTS

ACKNOWLEDGMENTS

First and foremost, I salute the members of the Historical Society of Dunkirk. These volunteers have dedicated themselves to preserving the history of a community, and because they helped safeguard a great number of documents and items, this book has been possible. I am especially grateful to city historian Robert Harris, historical society president Roy Davis, and vice president Pat Rosing for their continual assistance. This book depended on what those people accomplished before I started (see photograph on page 94).

I also thank Harold "Dick" and Barbara Lawson and their volunteers whose valiant efforts have preserved a Dunkirk treasure, the 1878 lighthouse.

The photographic and computer skills of Pamela Berndt Arnold made this book possible. I am eternally grateful for her assistance. In addition, Jane Currie and Kathleen Crocker gave valuable advice. Susan Hardy contributed her editing skills, Rodney Geiben his graphics, my nephew Alexander Andrasik his research, and Roberta Corcoran the final editing.

The making of this book was also made through the assistance of many others, especially those willing to share their photographs, documents, and information. To them, I say that in sharing those items you help continue interest in the city's history. A special thanks to my family and friends who were so supportive in the process of creating this book.

All images appear courtesy of the Historical Society of Dunkirk except for those whose contributors appear beneath their borrowed images.

INTRODUCTION

And on Point Gratiot, by our bay,
We can with truth sincerely say,
That on no other chosen ground,
Can more salubrious place be found.

—Henry Severance, 1891

Natives of Dunkirk know Lake Erie as our northern neighbor. It can seem odd that others have lived in places without a large body of water nestled nearby. Looking at a map of Dunkirk and its surroundings, Lake Erie seems to lie within the outstretched arms of the city; Point Gratiot protrudes northward on the city's western flank, while the sweep of Wright Park beach more gently ebbs to the east.

Each citizen of Dunkirk becomes familiar with the lake's moods, can interpret angry black clouds piling above it as an approaching storm, and can appreciate the reddish-orange glow of the horizon and lake surface as day ends. To these opposite scenes settlers came, attracted to the promise of the land and its proximity to the abundant source of fresh water offered.

Dunkirk historian Canon Leslie F. Chard summed up Dunkirk's earliest beginnings by saying that the city emerged from "out of the wilderness" just after the year 1800. Dunkirk has now had a little over two centuries of history. Its early efforts to establish a settlement set the tone for later struggles the community would strive to overcome. If the swampy nature and overgrowth of trees near the harbor hampered settlement in 1805, economic conditions would threaten the city in later years. Yet 200 years of history have been accomplished, and the city looks forward.

Early settlers like Seth Cole, Timothy Goulding, and Solomon Chadwick arrived to stay. In the ensuing 10 years, the community's transformation would be reflected in its names: from Chadwick's Bay, then Garnsey's Bay, and finally Dunkirk in 1818. Each successive name maintained that important link to the lake, with the harbor helping the city to establish and maintain its hope for prosperity.

Certain citizens gave impetus to Dunkirk's expansion. These included Walter Smith, Horatio Brooks, the Young Men's Association, and the immigrant. The first was Walter Smith, whose role in 1826 was that of a stimulating force. His business dealings caused Dunkirk to grow through lobbying efforts, smart business dealings, and assisting farmers and merchants.

The village alternately faced elation and despair. No sooner had the community incorporated as a village in 1837 then financial panic that same year nearly ruined it, bankrupting most merchants, reducing its population to nearly nothing. It was the declaration of the village as terminus of the railroad, in great part due to Walter Smith's influence, that renewed faith in it.

Thus the coming of the railroad in 1851 was the chief catalyst for the city's boom years. By 1850, the population rose to nearly 3,000 in anticipation of its arrival, and by 1900, it swelled to over 11,000 because of it. Industry and commerce of a wide variety sprang up, most importantly the Brooks Locomotive Works in 1869. The role Horatio Brooks played in giving birth to that industrial giant is inestimable, and the presence of that industrial giant provided a heartbeat for the city. It beat for 59 years.

Immigrants flocked here, first the Irish and Germans to build the New York and Erie Railroad, then to stay to make the village their own. The Polish came to work in the Brooks Locomotive Works and other factories, and the Italians followed. African Americans came after World War II, and Hispanic Americans arrived starting in the 1950s to work the farms. All were spurred to fill jobs in the factories and in the fishing tugs, to be farmers, cobblers, and grocers. They too played their roles in the city.

Harbor life also prospered. Commercial shipping kept the docks busy transferring freight to railroad cars. A grain elevator was built to handle grain shipments. Commercial fishing boats unloaded their cargoes to be sent by rail directly to larger cities.

The year 1880 brought with it Dunkirk being chartered as a city. A remarkable organization, the Young Men's Association, provided inspiration and leadership. It understood the importance of civic mindedness. Financial panics and depressions would affect Dunkirk as much as the rest of the industrial Northeast. Jobs would be lost and then regained. The city's population would ebb and swell. Layoffs were common. Businesses folded.

Yet within the ranks of its citizens, as well as government, were those who worked to improve the city's chances of success. Men with names like Hequembourg, Heyl, Bookstaver, and Mulholland, Blackham, Cummings, Monroe, and Toomey were interested in the growth of the city. They strove to help it adapt to changes being encountered. Others labored; Dunkirk was a city of workers, and their hard labor contributed to the city's success.

Into the second half of the 20th century, changes came more rapidly. Both the commercial shipping and fishing industries melted away. A protracted series of factory closings dealt harsh blows. The city's population diminished. Men like Walter Smith and Horatio Brooks seemed rare. The city has had to adapt and struggle to find its way in an increasingly complex international economy. Yet Chadwick's Bay, the city of Dunkirk, still stands, nestled by the lake, arms still outstretched.

One

THE EARLY YEARS

Dunkirk's history begins at its harbor, the French traveling along Lake Erie's southern shore in 1749 and 1759 on military missions. In 1790, Andrew Ellicott, surveyor general of the United States, crossed the area that Dunkirk now inhabits. In 1798, others surveyed the harbor, and Dunkirk developed from that harbor area. Its swampy, overgrown shore hampered settlement; historian Obed Edson stated, "The dismal woods came down to the very shore of the lake." Yet some realized its possibilities, including Zattu Cushing and Seth Cole. Cushing passed through in 1799 and purchased land parcels at Point Gratiot and Canadaway Creek. Subsequently Cole bought part of Cushing's property and settled near the creek after arriving with Cushing by ox-drawn sleigh in the winter of 1805. Timothy Goulding's family settled a mile west of the harbor in 1808. In 1809, his brother-in-law Solomon Chadwick built his cabin on the harbor shore, leading it to be known as Chadwick's Bay. By 1810, the first vessel arrived in the harbor.

Daniel Garnsey purchased Chadwick's land in 1817, and the area came to be called Garnsey's Bay. As Chautauqua County's first district attorney and representative, he worked to improve lighthouses and harbors, and soon steamboats and schooners regularly arrived from larger cities. In 1818, when businessman Elisha Jenkins visited Dunkerque, France, he noted the resemblance of its harbor to that of his own village. Returning home, Jenkins advocated changing the village's name to Dunkirk.

Dunkirk struggled to grow, with no more than 50 people residing there in 1825. When Dunkirk was considered as terminus of the Erie Canal and New York and Erie Railroad, even DeWitt Clinton purchased local real estate, and Walter Smith moved to Dunkirk in 1826. But excessive land speculation caused financial panic; the real estate and shipping industry collapsed, bankruptcies affecting even Smith. Yet once again, news the village would be the railroad terminus restored confidence.

Several historians assert that the 1851 arrival of the New York and Erie Railroad in Dunkirk marked the end of the pioneer period for both Dunkirk and the county. The railroad linked communities, the flow of people and goods increased, and Dunkirk prospered.

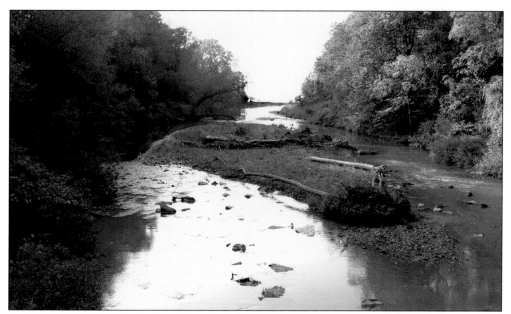

Seth Cole arrived at the banks of the Canadaway Creek in the winter of 1806, having traveled from Buffalo to Dunkirk over the frozen lake, an easier route than overland. Cole, his wife, and 10 children lived in a cabin that he constructed on the creek's east bank.

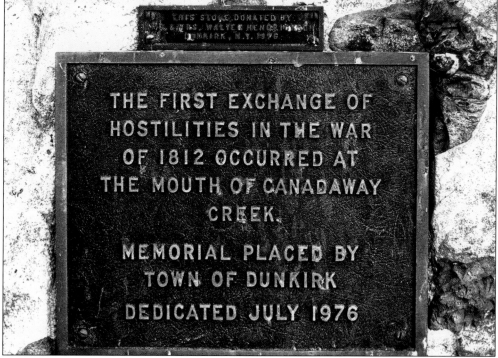

THIS STONE DONATED BY
MR. & MRS. WALTER MENOR HAGCH
DUNKIRK, N.Y. 1976

THE FIRST EXCHANGE OF
HOSTILITIES IN THE WAR
OF 1812 OCCURRED AT
THE MOUTH OF CANADAWAY
CREEK.

MEMORIAL PLACED BY
TOWN OF DUNKIRK

DEDICATED JULY 1976

This road marker testifies to the strategic importance of the 40-mile stretch of shore along Lake Erie during the War of 1812. Villagers became involved when Dunkirk's 162nd Militia Regiment drove back the men of the British schooner *Lady Provost* as it attempted to capture a salt boat that had taken refuge in the Canadaway Creek. (Photograph by Diane Andrasik.)

In 1808, a traveler noted that the village possessed no more than 20 houses, its failure to grow due to overgrowth of timber along the shore and harbor, along with difficult road passage. Sampson Alton's building of Dunkirk's first brick house, made from the clay in the harbor on Front Street, portended a greater stability to come. George A. H. Eggers sketched the building some years later.

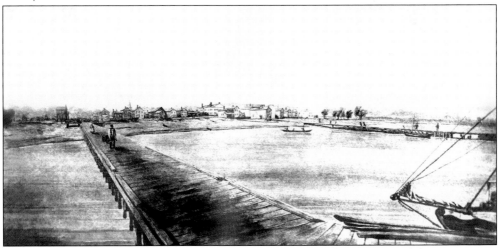

The oldest image of Dunkirk was this rendering by Eggers of a painting of the community in 1835. It reveals how marginal the community remained with its simple wooden wharf and harbor around which the small village nestled. A large white house sits in the center of the scene, occupied by Walter Smith. Another dock stretches to the right.

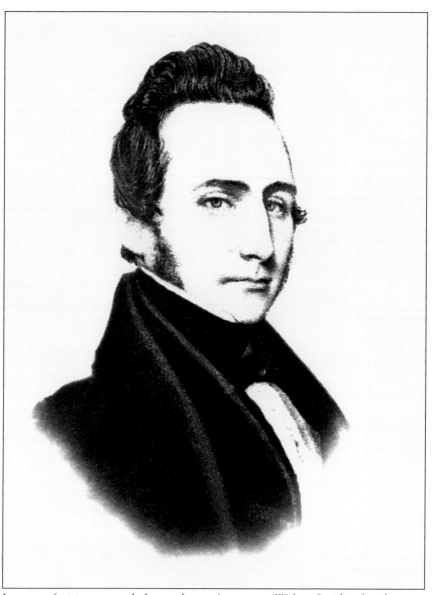

A single man of vision spurred the settlement's success. Walter Smith, already a successful merchant in Fredonia, moved to Dunkirk, and his role in its development caused him to be termed the true "founder of Dunkirk." One historian believed Smith's "life was a masterly and persistent struggle . . . often under adverse fortunes, to build up a commercial town at Dunkirk." He and financier DeWitt Clinton formed the Dunkirk Land Company to convince others to invest in the area. He started a freight service to assist shipping, convinced Buffalo ship owners to sail to Dunkirk, built the village's first gristmill, and shipped farmers' grain in his own three ships. He lobbied for Dunkirk to be the terminus of the New York and Erie Railroad. He financed construction of the Loder House, a four-story brick hotel named for the New York and Erie Railroad's president. It symbolized the city's hope to be the railroad's terminus. His building confidence in the area caused its population to increase to 628 by 1835, resulting in its incorporation as a village in 1837, governed by a board of trustees and president. Smith himself served as the first president.

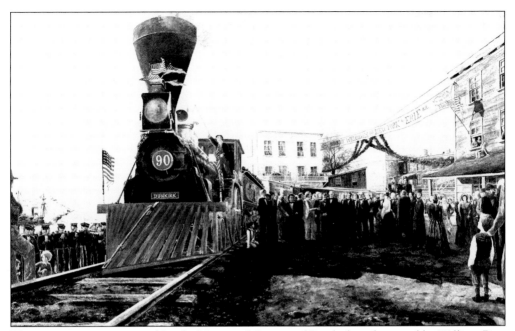

This painting commissioned by the Historical Society of Dunkirk and painted by William Burt in 1976 depicts Dunkirk's triumphant moment when the New York and Erie Railroad arrived at its terminus at Dunkirk on May 15, 1851. Its completion after 19 years created the longest railroad in the nation to that date—446 miles. The celebration brought over 15,000 visitors to the village of 2,900.

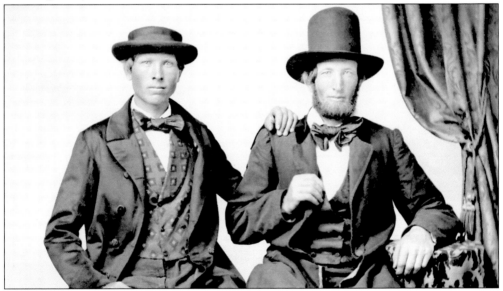

The first train into Dunkirk carried Pres. Millard Fillmore, most of the federal cabinet, the attorney general, the secretary of state, Daniel Webster, Stephen Douglas, Commodore Matthew Perry, New York governor Washington Hunt, and prominent state officials and merchants. This tintype captured two passengers on that first train. In 1887, the city's five railroad lines carried 42,903 persons through Dunkirk. Within a few years, 52 passenger trains stopped in the city daily, plus freight trains.

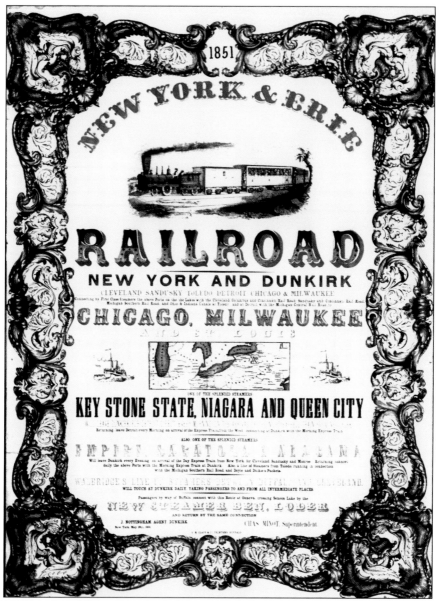

This 1851 poster establishes how the link between the railroad and the Great Lakes and Finger Lakes opened up the region for travel and expansion. The presence of the railroad is emphasized, a picture above the word showing a packed, open passenger car. The names New York and Dunkirk are linked together with several other cities like Cleveland and Detroit. Steamship and railroad linked these port cities and "First Class Steamers" to specific railroads. The Cleveland, Columbus and Cincinnati Railroad and the Michigan Southern Railroad would enable steamship passengers to reach Chicago, Milwaukee, and St. Louis. Canals assisted in finishing certain links. "One of the Splendid Steamers," such as the *Key Stone State*, promised to leave "every morning" on the arrival of the "Night Express Train from New York" for Detroit. Walbridge and Company's "line of steamers would stop at Dunkirk daily," making clear its role in serving as a midpoint between Buffalo and Cleveland. The map of the Great Lakes emphasizes the world opened to the mid-century traveler.

As early as the 1840s, Irish and German immigrants working on the railroad arrived in Dunkirk, and in 1865, Dolph Phillipbaar constructed a store and hotel that flourished alongside the railroad line on Third and Main Streets. Signs on the street and hotel were in German as well as English, the establishment attracting many of the German immigrants in the city as a social gathering place.

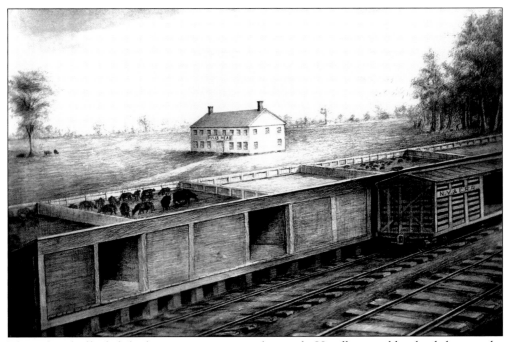

The railroad afforded the best way to transport livestock. Handlers would unload them at the stockyards owned by L. L. Hyde next to the line and feed and water them before journeying on. An advertisement in the *Dunkirk Journal* in 1855 proclaimed that 5,000 head of cattle and 20,000 sheep and hogs could be accommodated in the stockyard. The Bull's Head Inn Tavern stood in the field nearby, providing lodging for livestock drivers.

Construction of the state arsenal and armory in 1858 signaled the military importance of the area. During the Civil War, Companies D and E and later Company H of the 72nd Regiment were formed here. Dunkirk men would command each, and each commander would die in battle. The ivy seen in later photographs of the building was first planted by the widow of Civil War hero W. O. Stevens, killed at Chancellorsville.

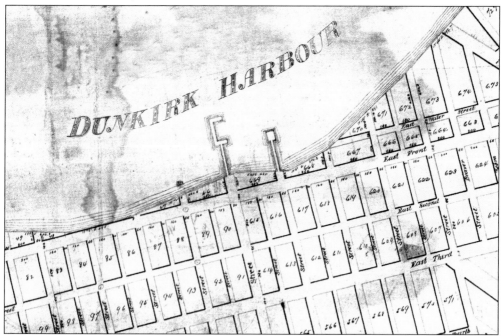

This 1836 map shows the village's proposed street layout. It was salvaged from the fire of 1924 that destroyed the old city hall. Only 15 streets actually existed then. Numbered streets ran east to west, including Second through Sixth Streets. Front Street, now Lake Shore Drive, followed the shoreline. DeWitt Clinton named streets west of Center Street (now Central Avenue) after birds and those streets east after animals.

Two

BROOKS LOCOMOTIVE WORKS

Steam locomotive power dominated transportation from the mid-19th to mid-20th centuries, and Dunkirk served an important role in that era. The Brooks Locomotive Works gave birth to over 13,000 steam locomotives, and five railroad lines made Dunkirk their stop.

The 1851 arrival of the railroad terminus brought jobs at the New York and Erie Railroad repair shops. This turned to near disaster when New York and Erie Railroad president Jay Gould and his board decided to close those shops due to financial problems. Horatio Brooks, then superintendent of that railroad, single-handedly turned the tide of Dunkirk's history by bringing together financiers who leased those shops from the New York and Erie Railroad and formed the Brooks Locomotive Works. Brooks served as president, with M. L. Hinman as secretary and treasurer, when the firm opened on November 11, 1869.

Over the next 59 years, the firm was swept along by national industrial events that included financial crises in the 1870s and 1890s. At times, the firm operated at great loss with widespread layoffs. The plant itself nearly closed. Yet in 1880, Brooks felt confident enough to construct new buildings and buy improved machinery, then to purchase the plant from the New York and Erie Railroad in 1883. In 1887, the year Brooks died, the firm employed 1,000 men, and by 1900, Brooks was the fifth-largest manufacturing plant in New York State.

The Brooks Locomotive Works yielded to the trend of business consolidation in 1901, as it merged with other locomotive companies to create the American Locomotive Company (ALCO). Producing diversified products extended its life, yet management later shifted locomotive production elsewhere. Brooks Locomotive Works produced its final locomotive in 1928.

The plant became ALCO Thermal Products in 1934, and again diversified production allowed survival amid growing economic difficulties throughout the industrial Northeast. In 1962, the facility was sold, but a group of Dunkirk citizens, led by Malcolm Reed and the Botta Bond group, campaigned to purchase the ALCO property, leading to formation of the Progress Park Industrial Complex. Roblin Steel, Plymouth Tube, Cenedella Wood Products, and Alumax Extrusions occupied the site. In time, these too would close or move. Dunkirk's railroad era would finally end.

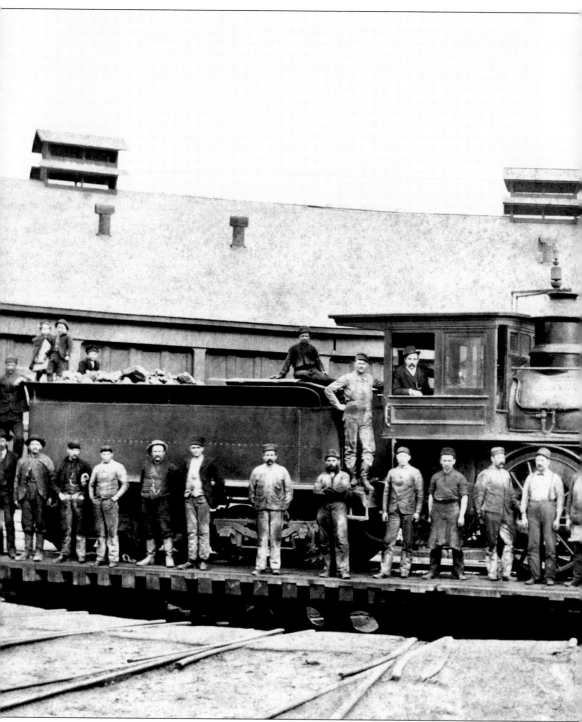

Management and the shop crew pose in front of the first engine produced at Brooks Locomotive Works in 1870. Brooks himself sits in the engine's cab. The engine was one of 25 that the New York and Erie Railroad ordered, the very firm that tried to close down the Dunkirk shops. The engines were 4-4-0s, a designation meaning the engine possessed four leading wheels to

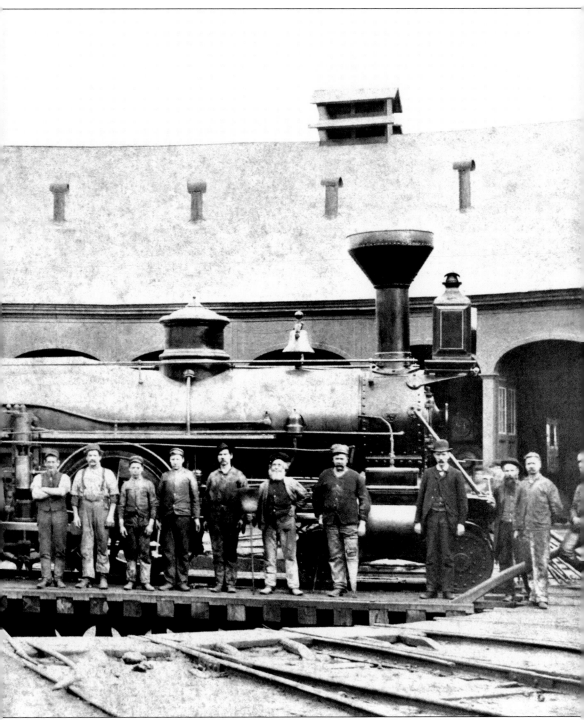

keep it on track, four driving wheels, and no trailing wheels. The turntable that the engine sat on allowed each engine that occupied the 20 stalls behind the turntable to enter its stall for servicing and leave it to gain access to the railway system. The turntable pivoted at the center and was supported at each end by wheels that ran on a circular track.

BROOKS LOCOMOTIVE WORKS,

Dunkirk, N. Y.

ORDERS SOLICITED FOR LOCOMOTIVES ADAPTED FOR EVERY CLASS OF RAILWAY SERVICE.

We invite Special Attention to our Complete System of

TEMPLATES AND GAUGES.

M. L. HINMAN, Sec'y & Treas. H. G. BROOKS, Pres't & Sup't.

LB- 2

Brooks Locomotive Works would produce engines for all the railroads in America and many foreign ones also. It built models such as the Mikado, Mallet, Mountain, and Prairie. Early railroad companies constructed rails with a gauge, the distance between their rails, which might differ from the gauges of other companies. By 1886, this was standardized to the Stephenson gauge of four feet and eight and a half inches. (Joseph Sweeny.)

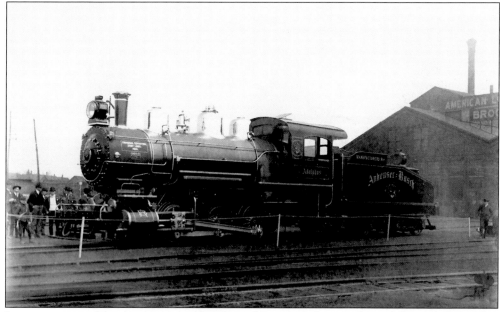

It was not unusual for companies to specialty order engines, having them elaborately painted in the plant's paint shop. Brooks Locomotive Works produced one such train for the Anheuser-Busch Company and displayed it at the Universal Exposition in St. Louis in 1904. It was named *Adolphus*, the name appearing under the cab window, in memory of Adolphus Busch, partner of Anheuser.

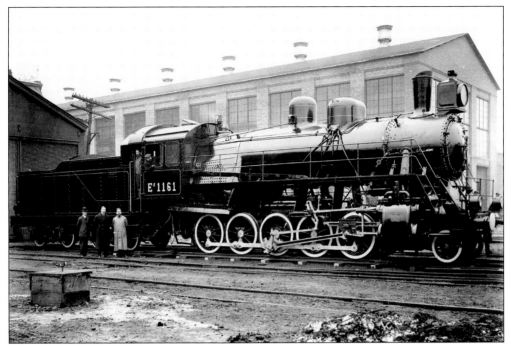

The Brooks Locomotive Works produced locomotives for many foreign countries, including this 2-10-0 built for the Russian government. The engines were tested at the plant, dismantled, and crated for shipment aboard steamships, to be reassembled at their destination. Men called "messengers" would accompany the engine to its destination.

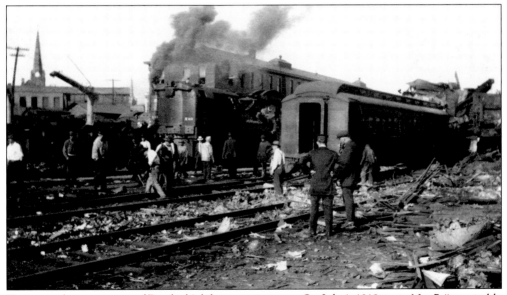

Train wrecks were a part of Dunkirk's life as a train town. On July 1, 1919, train No. 7, "a veritable engine of death" according to the *Dunkirk Evening Observer* reporter, crashed into passenger train No. 41 standing in the Dunkirk depot, killing 12 and injuring many more who had to be tended in hotels and private residences. This image shows the aftermath of the crash.

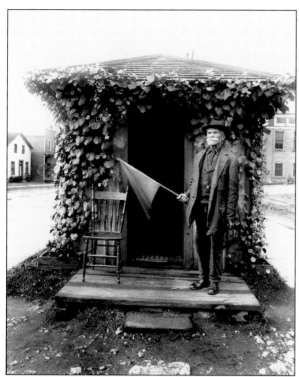

Flagman Pasqual Taddio manned his station at Third and Washington Streets in 1904, part of the signaling system used to warn any oncoming train of dangers ahead. In 1919, a flagman was sent east of the Dunkirk depot to warn oncoming trains of stalled train No. 41. Train No. 7 out of Buffalo signaled with two whistle blasts that it had seen the flagman, but its brakes failed, and it struck the rear of train No. 41.

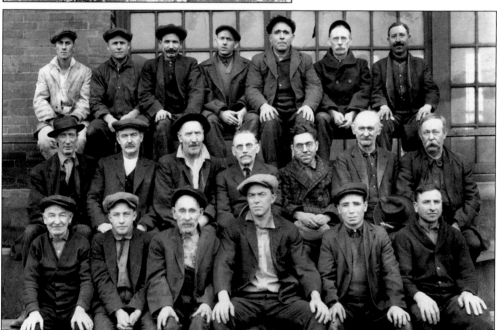

As its largest employer, the company's importance to the economic life of the community could not be understated. In 1901, the Brooks Locomotive Works paid in wages the sum of $1,386,636.16. Shown here is part of the workforce in 1923, the men of the paint shop. Their names reveal the melting-pot nature of the plant. The first row, from left to right, includes ? Baumgardner, ? Panowicz, ? Ormsby, Joe Zacharias, Sam Mancuso, and Sam Ceptanni.

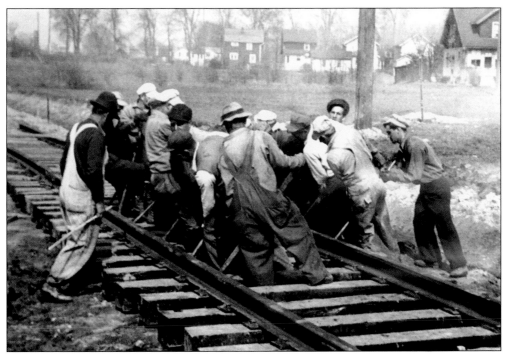

Hand crews, colloquially called gandy dancers, performed the arduous task of aligning newly laid track, here on the New York Central Railroad roadbed on Temple Street. These men used specialized hand tools known as gandies to lever the rails into position. Crews would later work to constantly realign the rails shifted out of position by the movement of the trains.

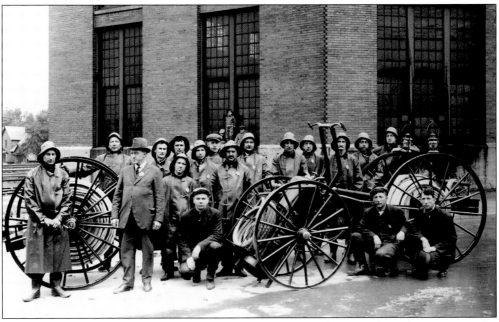

Members of the fire department of the plant stand in front of the paint shop after practicing fire suppression techniques. Three separate hand pumps were used at the plant, the one on the right being a chemical wagon.

To signal economic recovery, Horatio Brooks added an elegant administrative building to the company site in 1880. Offices occupied the ground floor, while engineers worked on the second. The third was used as a school for apprentices, the only vocational education available in the city until the public schools introduced a program in 1914. Required to be 18 and know English, apprentices attended school three nights a week after their usual 10-hour workday.

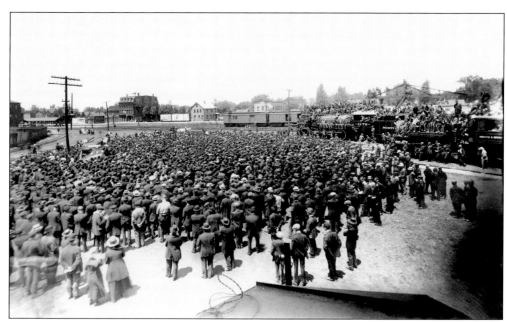

After completing an order for the Northern Pacific Railway for 150 Prairie type 2-6-2s, the ALCO president congratulated the assembled workers in May 1907. The Northern Pacific Railway purchased some 600 locomotives from Brooks Locomotive Works.

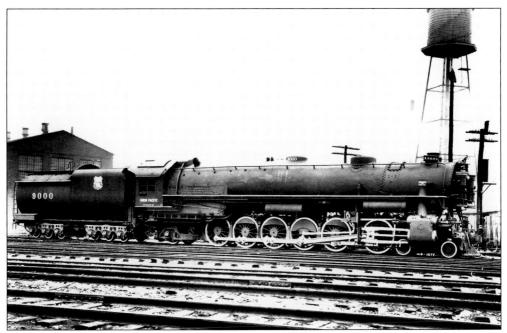

Locomotive No. 9000 was a monster, a 4-12-2 weighing 782,000 pounds, having a horsepower of 4,330, and carrying 21 tons of coal and 15,000 gallons of water. Built in 1926 for the Union Pacific Railroad, it had 4 leading wheels, 12 driving wheels, and 2 trailing wheels. This type of engine was used to haul freight through the mountains.

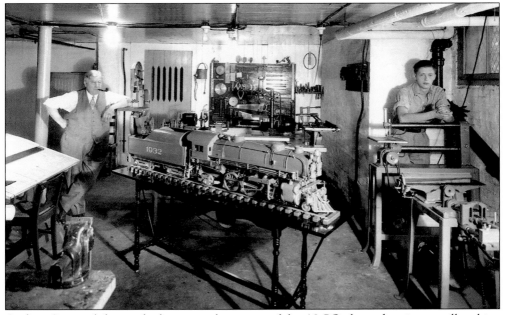

Andrew Swoyer, left, was the last general manager of the ALCO plant when it was still making engines. He constructed this six-foot-long, wooden, working model of a locomotive after his retirement in 1930. At his death, his obituary stated, "He was one of the nation's builders. He was one of the last survivors of an era of industrial captains who worked with their men on a basis of friendship and high mutual respect."

This locomotive's size can be understood by its wheel size relative to the people standing in front of it. The Brooks Locomotive Works and the five generations of men who worked in the plant constructed 13,245 locomotives between 1869 and 1928, on average 3 engines every working day. In its best year, 1901, the plant produced 382, while its worst, 1874, saw only 6.

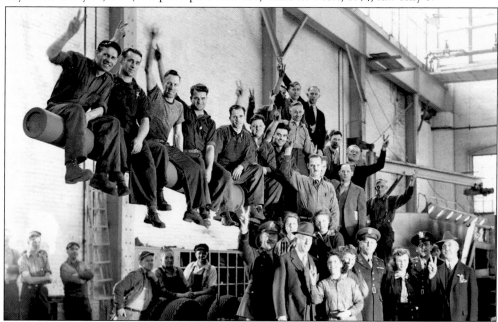

During World War II, the plant focused on production of two models of the 155-millimeter artillery gun called the Long Tom. With a weight of 30,600 pounds, and its barrel 40 feet in length, the gun could fire a 95-pound round up to 15 miles. The plant's 800 employees also made parts for steam locomotives shipped to Russia under the Lend-Lease Act. Their contribution to the war effort caused the plant to receive a presidential citation.

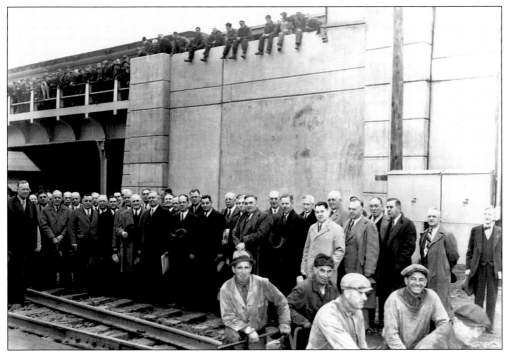

For 90 years, rail lines ran at ground level along Third Street, a situation that encouraged business growth there but which also contributed to accidents involving trains. In the 1940s, the New York State Department of Public Works Grade Elimination Project changed that, raising the level of the tracks. Workers and railroad officials gather here to close the old and open the new roadbed.

The plant's workforce took an active part in community projects. Here worker representatives and plant and city officials pose at the gates to celebrate reaching their goal for a community chest drive in 1950. Plant manager Hugh Corrough stands in front of the sign.

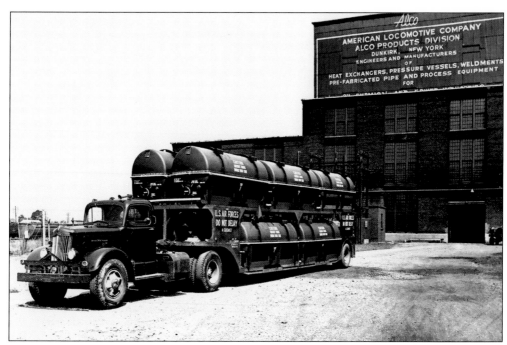

As ALCO Thermal Products, the plant made custom-made oil refinery equipment, heat exchangers, and custom products for power plants and water treatment facilities. It made the component parts of the Triborough Bridge and tunnel shields for the Hudson River Tunnel. Starting in the later 1940s, it produced such things as nuclear power plant parts and engine containers for the U.S. Air Force, shown here.

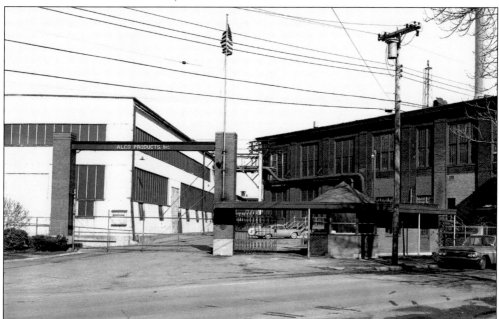

The main gate with its guard shack stands on Roberts Road, a common sight for thousands of workers who used it to enter the plant grounds. In 1921, the plant as ALCO employed 4,500 people in a city of 19,000. At its closing in 1962, the final 750 workers were laid off.

Three

CITY OF INDUSTRY

Early in its history, Dunkirk seemed focused on development of its harbor and shipping. Lumbering was an important early industry, as the clearing of forests contributed to the building trade. Yet by the 1860s, lumber came from other states to be milled, and the city's industry diversified.

By 1887, the city's five railroad lines readily connected it to places east and west. The emerging Brooks Locomotive Works centered heavy manufacturing on the railroad and its supplies. However, a 1894 pamphlet called *Dunkirk as It Is and Its Possibilities* stated that "56 manufactories," factory sites where diverse goods were being manufactured, existed then. Other statistics bear this out. That same pamphlet boasted that an "industrial investment of $2,810,000" had been made in the city, revealing the strength of that diversity. Some 2,800 were employed at manufacturing plants in a population of about 12,000. The state census reported that in 1915, all factories of the city employed 4,350 in a population of some 18,000. These numbers dropped during the Depression, then rose steadily to equal that number. The influx of immigrants eager to work at hard industrial jobs and the presence of shipping and railroad transportation inspired industry to grow.

The city's industries made crucial contributions to the efforts of both world wars. ALCO made bombs for the British army in World War I and heavy artillery guns for the American army in World War II. The defense department constructed one of the main buildings at Allegheny Ludlum so it could produce war material. Dunkirk Radiator also produced armaments in the early 1940s, assembling hand grenades, bomb noses, and land mines

Working conditions were hard, and pay was often low. One contract recorded a man's pay being 18¢ an hour in 1875, and another wrote in a *Dunkirk Evening Observer* article that a man could work at Brooks Locomotive Works all day for $2. Yet immigrants flocked to Dunkirk, where they and their descendants were responsible for building a city of industrious workers.

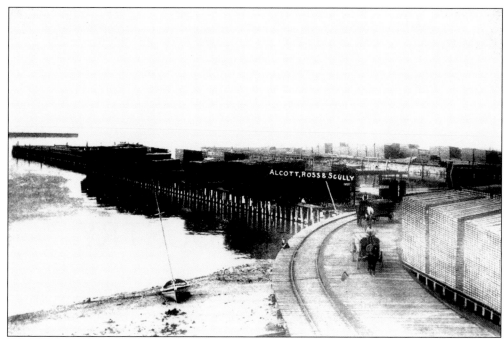

Plentiful forests resulted in a number of firms manufacturing lumber products. Barber, Scully, and Company, started by David Wright in 1865, covered six acres on the shoreline. It had its own dock and handled 12 million feet of lumber each year. One article reported its average daily shipments included 300 doors and 300 windows. The Alcott, Ross, and Scully Company followed, bringing wood from Lake Superior and employing 225.

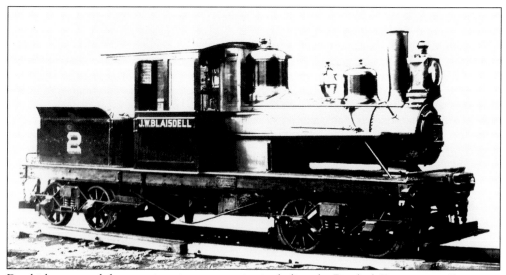

Dunkirk possessed three engineering companies, including the Dunkirk Engineering Company, successor to the Dunkirk Iron Works. Created in 1865 to manufacture boilers and stationary steam engines, by 1882, it was producing logging cars and geared locomotives such as the one shown, a J. W. Blaisdell No. 2 Class B "Dunkirk." The business ended in 1896.

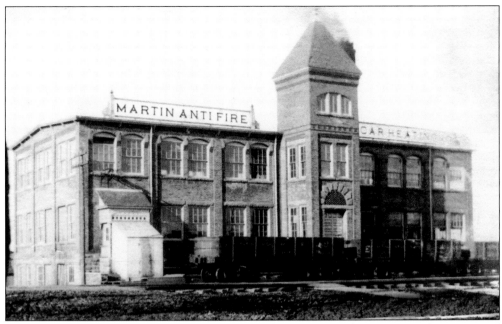

Locomotive travel brought dangers, including death and injury, when train wrecks overturned stoves used to heat passenger cars, causing fires. William Martin, a machinist turned minister, solved the problem in 1882 by using steam heat from the locomotive itself. He then formed the Martin AntiFire Car Heater Company and built a factory in 1889 to produce his patented invention. It was used in 5,000 cars and engines before the business folded.

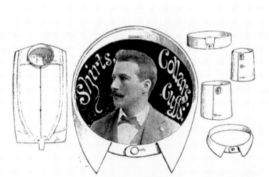

Largest New Shirt Laundry in Western New York.

@@@@@@@@

CUMMINGS'
New Shirt Laundry

207 Central Ave.,

DUNKIRK, N. Y.

A. W. CUMMINGS, Prop'r.

Our Specialty:—New Shirts, Collars and Cuffs—High Gloss or Domestic Finish.

———————————— Patentee and Owner of the Celebrated ————————————

CUMMINGS' TURN=DOWN COLLAR FOLDER
The Only Machine That Will Shape a Turn-Down Collar Without Breaking It.

Cummings' Collar and Cuff Starcher and Wiper...Cummings' Tip Collar Ironer for Ironing the Points of Standing Collars...Cummings' Tip Collar Turner for Turning and Pressing the Tips of Standing Collars Without Breaking Them.

Owners W. H. Cromwell and A. Williams started the Dunkirk Shirt Company in 1883 with 24 machines, later 92. They employed 150 women. Boasting that wages for the women amounted to $400 per week, the owners noted they were thus "bringing material assistance to very many families in this city." Their "Cromwell shirt" and "Dunkirk shirt" were sold throughout the country. To make the 300 shirts ordered per week required 10,000 yards of material.

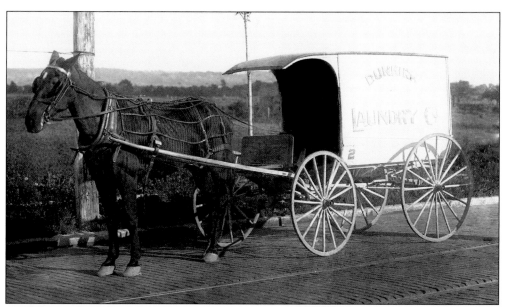

In 1886, A. W. Cummings and F. B. Rice opened the steam Dunkirk Laundry, first known as the Home Steam Laundry. Owners contracted with the Dunkirk Shirt Company next door to put finishing touches on shirts. The business flourished, reaching out to a radius of 100 miles and employing 30, including the delivery wagon drivers.

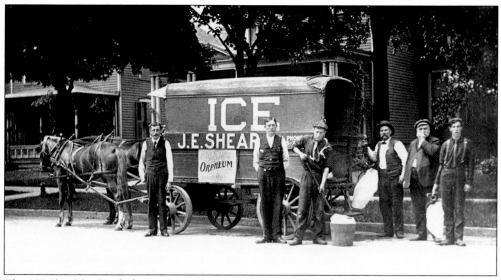

The 1886 booklet *Dunkirk* noted, "In this place the natural product [of ice] is easily secured from the clear surface of the bay." Thus the weather and the lake afforded opportunity for men like Koch, Gunther, and Dotterweich to store ice for summer use, as well as J. E. Shear. Here in 1909, his wagon delivered ice to a top customer, Henry Smith's saloon. A 100-pound cake cost 25¢. Saloon owners paid less.

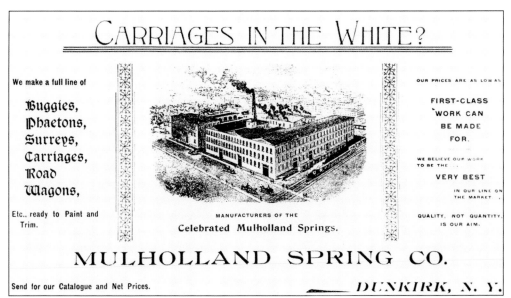

Horse-drawn conveyances were improved in 1881 when Richard Mulholland formed the Mulholland Spring Company relying on his "Mulholland Spring" patent. The company produced the device, which eliminated "sidebars, side-springs, etc., allowing the vehicle to turn short and placing the weight directly over the axles" of their buggies, phaetons, surreys, carriages, and road wagons.

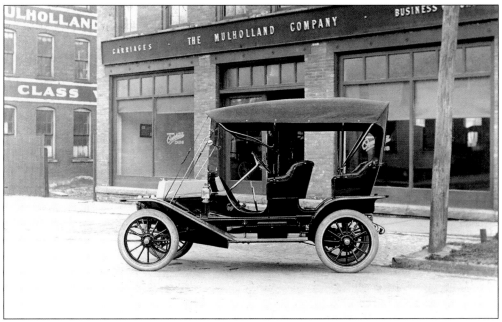

Companies learned to change with the times. With the shift in transportation modes, Mulholland turned to making automobile parts like springs and drive shafts, then truck and ambulance bodies that fit onto Ford frames for the U.S. Army in World War I. In the 1920s, it produced roadside diners, to answer "the demand for good food, served cleanly and quickly at reasonable prices."

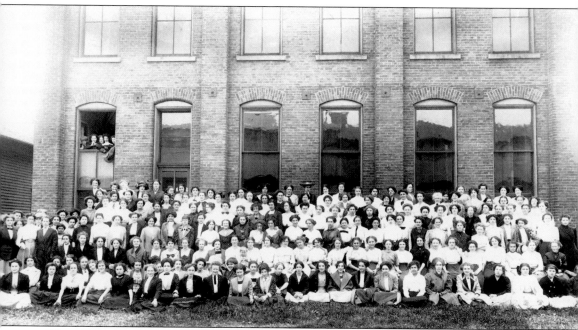

When Ezekial and Zealie Van Raalte opened their Van Raalte Company plant in Dunkirk in 1917, it provided a major source of employment for Dunkirk's women. It was said that "the silk mill supported Dunkirk during those dark days" of the Depression, and it became Dunkirk's largest employer in 1937. The plant continued until 1964, employing the author's mother, Genevieve. Former worker Lillian Pencek wrote that she started working at the mill after school when she was 12, getting 25¢ an hour "tying and dragging on gloves," then quit school at 14 and "got a job on a machine, closing gloves." After her marriage, she would quit to have children but would return to work after her husband was laid off at the steel plant.

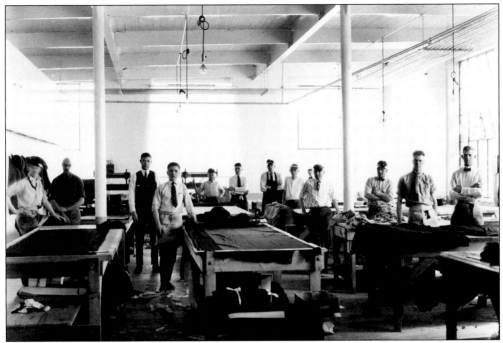

Hosiery cutters shown here at the Van Raalte Company plant in the 1920s include Bill Ebert and Eagle Gaken. The company specialized in the manufacture of ladies' underwear, stockings, and gloves. By working with DuPont, the plant helped pioneer the use of nylon for undergarments and produced mosquito netting, parachute flares, and woolen gloves for the war effort.

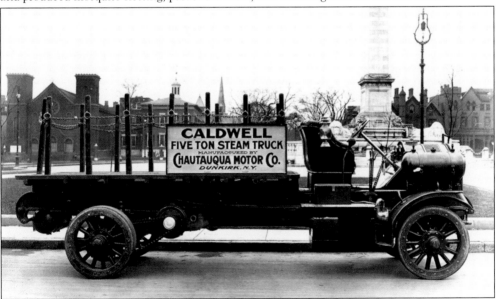

The early 1900s saw small manufacturing firms producing cars or car bodies. Such was the case for the Chautauqua Motor Company, which in 1910 built a seven-and-a-half-ton steam-driven truck as well as a five-ton truck, purchased by a Chicago coal company and the Baldwin Locomotive Works. Note the chain drive on this truck. The firm eventually focused on producing worm gear rear axles.

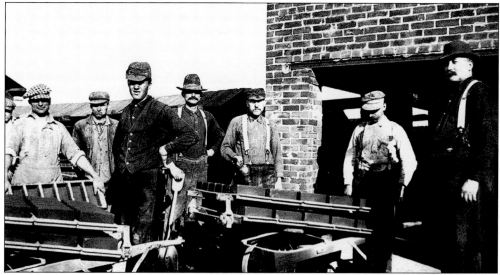

JOHN HILTON. WILLIAM HILTON.

J. & W. HILTON,

Manufacturers and Dealers in

Brick & Draining Tile

Of all Sizes;

Front Street, about One Mile west of the Post Office,

DUNKIRK, N. Y.

All Orders Promptly Attended to.

When immigrants arrived in America, they brought skills from their country of origin that allowed them to take up a trade in their new country. So it was for John Hilton, an Englishman who came to America from a family of brick makers before 1850. Hilton set up business with his brother William, later splitting into separate businesses. (Janet B. Klopfer.)

An 1896 advertisement stated Hilton's brickyard had the capacity to make three million bricks annually, resulting in Hilton brick being shipped to other counties and states. John Hilton's son Walter Hilton, who stands at the right, invented a "paddle machine" for making brick. Its modern equivalent is still used in brick manufacture today. Walter's business would be destroyed by an intense windstorm. (Janet B. Klopfer.)

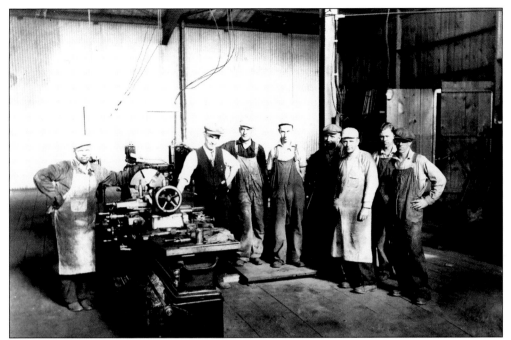

Dunkirk Radiator Corporation helped the city earn the title "Heating Center." It manufactured residential hot water and steam boilers in its plant on Middle Road. Founded in 1928 by Earle Reed, it produced armaments in the early 1940s, hand grenades, bomb noses, and land mines. At the end of the war, it returned to producing heater systems and boilers, continuing to do so today.

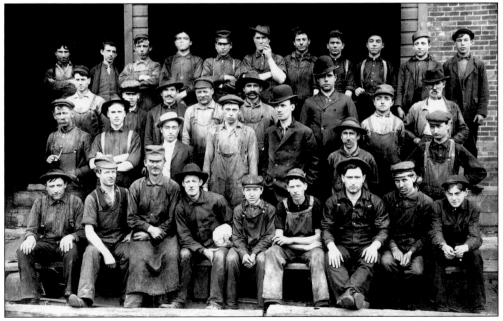

The United States Radiator Corporation's eight plants included the Dunkirk facility, formerly the Harrell Steam Heating Company. The back of this photograph identifies it as "Jacob Manni and his gang," who were members of the mechanical repair department of the plant around 1915.

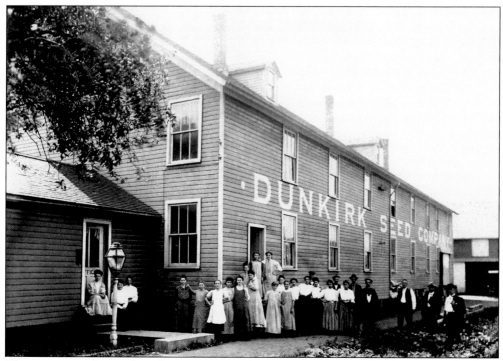

The existence of several seed companies in the area gave proof of its agricultural diversity. The Dunkirk Seed Company, established in 1888 by the Wright brothers, grew from 175 to 1,000 acres by 1896, by which time it was buying seed from England, France, Germany, and the western states.

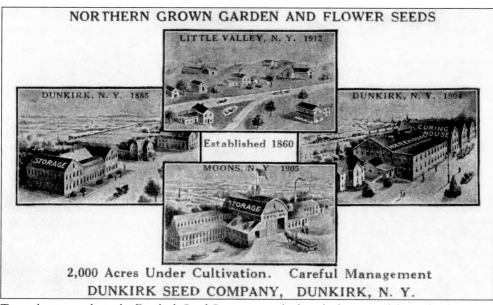

NORTHERN GROWN GARDEN AND FLOWER SEEDS

LITTLE VALLEY, N. Y. 1912

DUNKIRK, N. Y. 1885

DUNKIRK, N. Y. 1904

Established 1860

MOONS, N. Y. 1905

2,000 Acres Under Cultivation. Careful Management
DUNKIRK SEED COMPANY, DUNKIRK, N. Y.

To market its product, the Dunkirk Seed Company packed seeds that were delivered to key cities around the country, where one of the company's 15 salesmen would pick them up and deliver them to stores. Salesmen might be on the road six months distributing seeds. The company also manufactured a line of Wright's Cough Cure and Wright's Little Liver Pills. (Joseph Sweeny.)

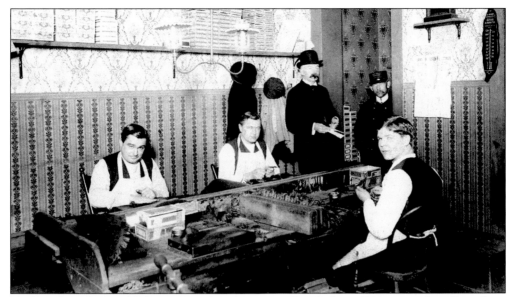

No less than five establishments produced cigars in Dunkirk in 1880, not only selling them locally but shipping large quantities elsewhere around the state. Tobacconists like George P. Isham, John Meiers, and James Rogan advertised such brands as the CMBA, five-cent brands, the G.P.I., and the American Gentleman.

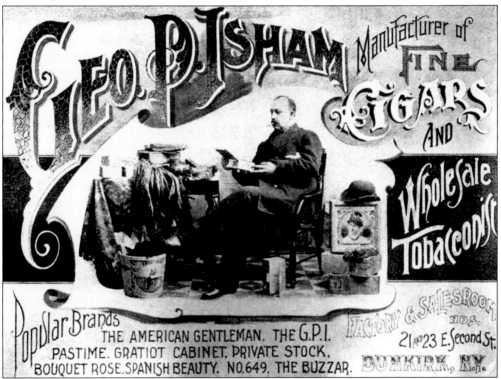

Isham sits in his chair gazing into an open box of cigars. Raw tobacco leaves lie on the table nearby, and types of cigars produced by his company rest on the table and the floor. In 1882, the Isham firm produced 1.25 million cigars with the help of 20 employees.

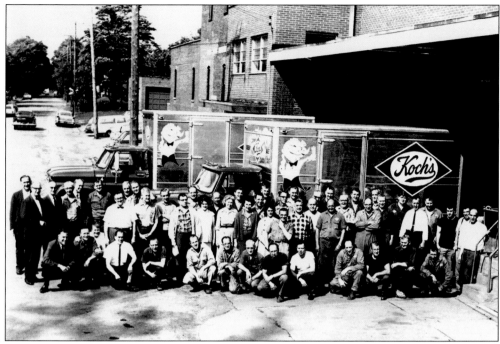

The Fred Koch Brewery started in 1888, becoming a city institution whose Golden Anniversary Beer ranked first among 140 American-brewed pale lagers in the *Gourmet Guide to Beer* in 1983. Its plant reached production capacity of 100,000 barrels a year. Early-1900s contracts stipulated, "Beer shall be given free during lunch breaks." Their workers formed the first union in the city. (Elvin Dutton.)

The Fred Koch Brewery epitomized the small business whose eventual demise reflected the trend of the inability to compete against larger corporate entities. In the 1970s, it was one of only 50 independently owned breweries in the country. It survived Prohibition by bottling springwater and soft drinks. According to union president Elvin Dutton, "Not a single day of production [was lost in] . . . sixty years because of a labor dispute." Nevertheless, it succumbed in 1986. (Elvin Dutton.)

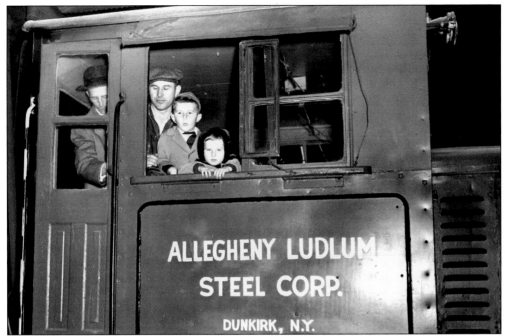

The Atlas Steel Corporation formed in 1907 and established the eight-hour workday in 1918, the first to do so in the country. In 1938, the Dunkirk plant became part of Allegheny Ludlum Steel Corporation and then celebrated its 40th anniversary with an open house, with a train providing transportation between two plant complexes.

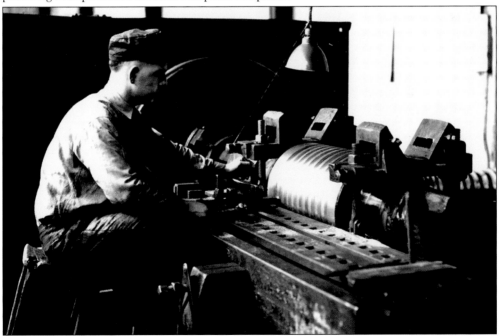

The original plant on the Lucas Avenue site of Allegheny Ludlum Steel Corporation was a wire mill. The worker seated at the cylindrical mill roll here in 1938 operated a lathe and kept a set of calipers hanging near his knee to check the size of the roll.

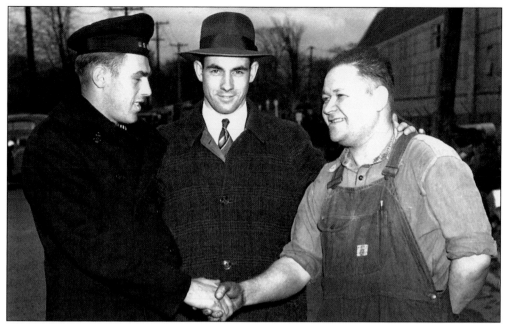

The defense department constructed the Brigham Road building of Allegheny Ludlum Steel Corporation in 1942 to make war material. In 1942, shipfitter first class Ed Pryll and a representative from the Department of Labor visited the plant and met workers turning out war tools. Pryll told the men his story of being torpedoed off Guadalcanal. Ed Borgeson, war production drive committeeman, shakes his hand.

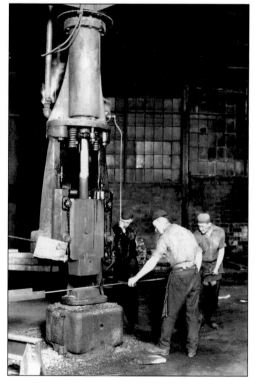

Three men operate a hammer press at the Allegheny Ludlum Steel Corporation plant sometime in the early 1940s. The press strengthened the steel for the next operation in the production process.

In 1976, Dunkirk faced loss of its steel-making industry. Chief executive officer Adolf Lena along with seven management employees created the AL Tech Specialty Steel Company. It became the city's largest employer. The plant produced bar, wire, seamless pipe, and other stainless steel products. Here Rick Holly attaches identification tags to bars ready to be shipped.

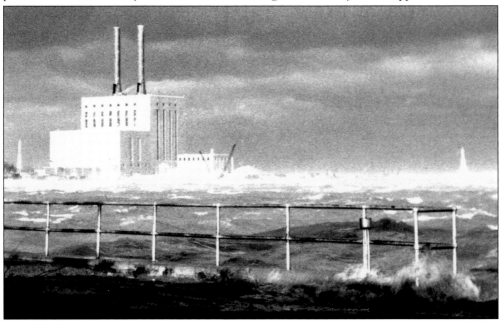

John Harris photographed the Niagara Mohawk Power Corporation Steam Station during a bad storm in 1949. The coal-fired station was constructed in 1946, at the time pumping 660 tons of water per minute through condensers to condense steam. The presence of a breakwall and warm water emitted from the plant resulted in the inner harbor no longer freezing.

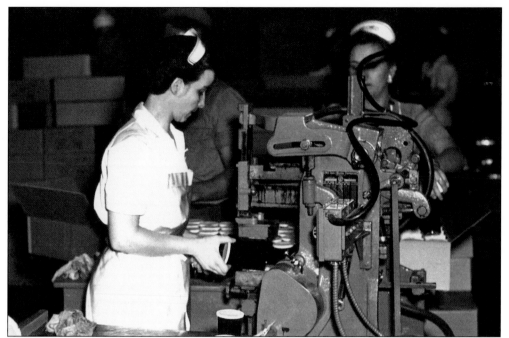

Bedford Products occupied the Dotterweich Brewery property in 1940. It focused on canning 16 varieties of jellies but also produced fruit juice, providing concentrate to Kraft. Buell Bedford commented that his firm made gross sales of $765,000 in 1943 because "we always made the finest quality . . . [and] no one in the organization was afraid of work." Bedford Products later occupied a plant on Talcott Street, eventually becoming part of Kraft Foods.

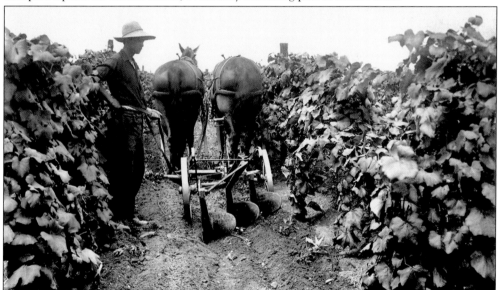

Dunkirk's location within the Chautauqua Grape Belt that follows Lake Erie's shoreline has allowed it to benefit from the grape-production industry. A *Dunkirk Evening Observer* article noted that the 1919 grape crop was immense, amounting to 49,212 tons and valued at $4,622,411. Railcar loads of grapes from the years 1909 to 1913 varied from a low of 95 to a high of 401. Bedford Products, Kraft Foods, and, more recently, Cliffstar handled juice making in the city.

Four

THE CITY AND THE LAKE

Dunkirk and Lake Erie have had a 200-year partnership. The lake has provided economic support through fishing and shipping industries. Dunkirk's citizens established parks where people enjoyed swimming, boating, picnicking, and brilliant sunsets from Wright Park and Point Gratiot.

Dunkirk's citizens also observed the lake's dangerous side. In 1841, the steamship *Erie* exploded in flames off nearby Silver Creek. Boats from Dunkirk attempted to rescue passengers, but 200 died. The schooner *Golden Fleece*, the fishing tug *Sachem*, and many others have fallen prey to sudden storms on the lake.

The booklet *Dunkirk* of 1880 claimed, "The fishing interests of Dunkirk present a field for almost unlimited development, as the broad lake is before us, and . . . small boats, as well as large ones, could not only make a safe and convenient landing, but would have ample anchorage and proper protection from the winter's storms in our beautiful bay." The writer of the book believed all reasonable "encouragement" should be given to the men "who take hazards and hardships of a fisherman's business and bring products from the bosom of Lake Erie." This the people of Dunkirk succeeded in doing, beginning with James Maloney from Ireland, the first to fish with gill nets from a rowboat, in 1851. The Canadian Johnson brothers, who first used "night-lines" with baited hooks, were among the many who continued the trend.

The Great Lakes gave rise to the fishing boats known as fishing tugs, and the year 1884 saw the arrival of the steam tug *Ruby* from Conneaut, Ohio, a 40 footer. Others followed suit, until between 1890 and 1913, over 125 fishing tugs operated out of Dunkirk. The Desmond Fish Company alone would send out 14 tugs to fish by the year 1914 and bring in as much as 77 tons a day. In 1913, Dunkirk shipped out 3.5 million pounds of fish.

It is no surprise that each attempt to name the community proved its partnership with the lake, its first two names relating it to the harbor itself and the third and final name to a similar harbor in a foreign country.

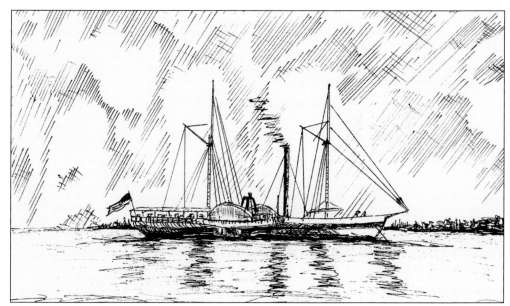

The first lake vessel appeared at Dunkirk's harbor in 1810, with a permanent wharf built in 1828. The first steamboat to navigate Lake Erie, the *Walk-in-the-Water*, stopped regularly at Dunkirk by 1818, when it made its weekly trip from Black Rock, near Buffalo, to Detroit. Lake passage provided a quicker means of passage to the area and points farther west, helping to increase the flow of immigrants and trade. (Drawing by Rodney Geiben.)

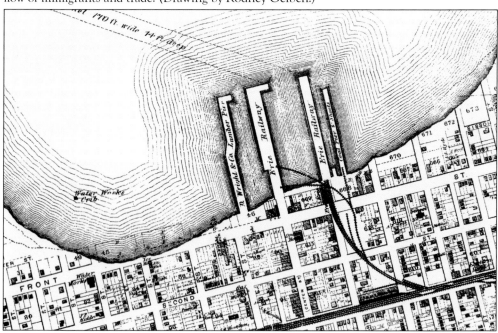

This 1887 map reveals four docks operating. At far left, ships unloaded wood for the mill at the Eagle Street dock. The New York and Erie Railroad dock at Center Street held the covered warehouse and grain elevators. Immigrants disembarked from trains to board steamers heading west at the railroad freight house at Washington Avenue. The coal pier's chutes moved coal from trains arriving from Pennsylvania onto ships headed for Buffalo and Canada.

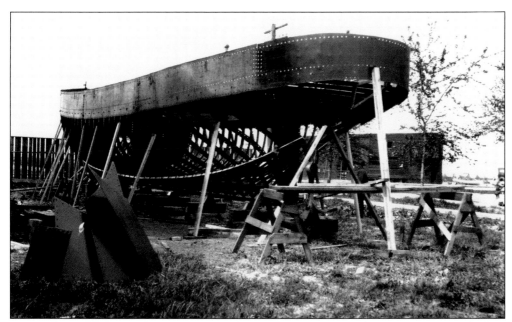

Capt. Albert E. Baker and sons built the *Albert E. Baker* in the Taylor Mill yard in Dunkirk in 1924, its ribs and deck supports constructed of steel. It was 65 feet long and 15 feet wide, with a 30-ton displacement and four watertight bulkheads. Only the second steel tug built in Dunkirk, it was called "one of the staunchest and best built fishing boats on the Great Lakes" and valued at $25,000.

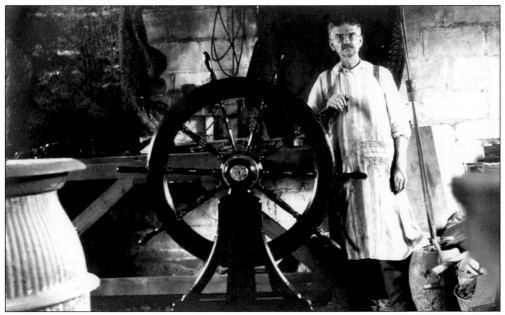

A carpenter stands next to the wheel he built for the *Albert E. Baker*. Tugs would operate with a captain, engineer, and crew of two or more, the captain steering in the pilothouse, which at first was the only enclosed area of the boat. When steam-powered lifting nets were adopted, the decks would also be enclosed by a superstructure that protected the men from the elements, especially for when boats were used in winter and early spring.

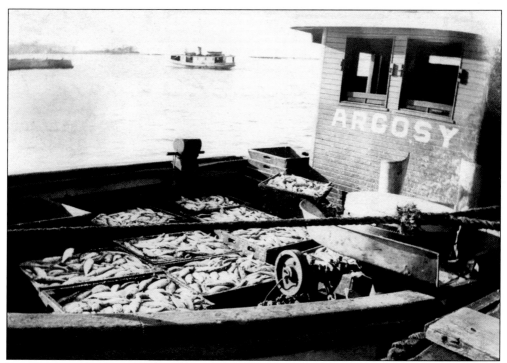

Fish boxes on the *Argosy* await offloading at the dock in 1918. Tugs came to port loaded with whitefish, trout, blue and yellow pike, herring, ciscoe, and sturgeon, whose roe was exported to Germany, processed into caviar, and in turn reimported into the United States.

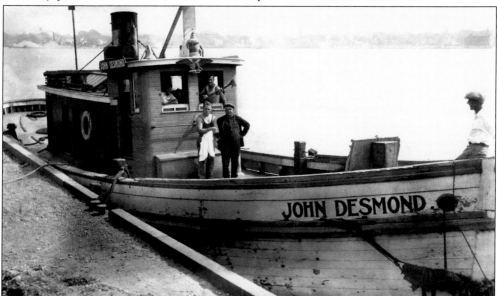

The *John Desmond* was the fastest tug on fresh water, the pride of the 14-boat fleet of the Desmond Fish Company. Some 125 tugs operated out of Dunkirk between 1890 and 1913, steam or gasoline driven, 40 to 70 feet long. Built sturdily to withstand heavy seas, the *John Desmond* could break through early spring ice but was irreparably damaged in a violent lake storm in 1929 that destroyed the dock and two other tugs.

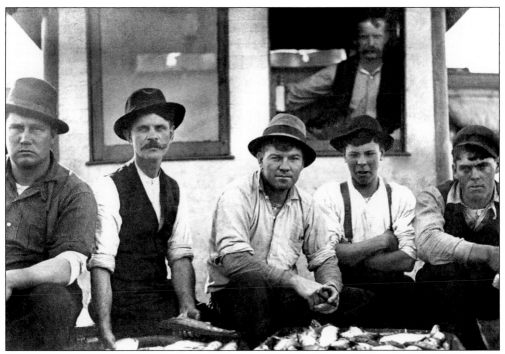

A 1905 *Dunkirk Evening Observer* article reported 27 tugs used Dunkirk as their headquarters, involving about 200 men, such as those pictured. The crews earned about $75,000 in wages. On one day in 1905, the Buckeye Fish Company caught 45 tons, for which the men were paid 2.5¢ per pound. This led to a strike by the men for a higher return.

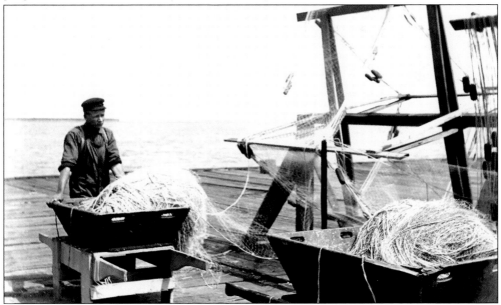

A man stands at the drying racks for nets on one of the fishing docks in the early 1900s. Nets used here in the 1850s were homemade five- or six-inch mesh nets, weighted down by large flat stones. According to a *Dunkirk Evening Observer* article, about 200 men were employed in the fishing industry by 1905, with another 600 dependent on the trade.

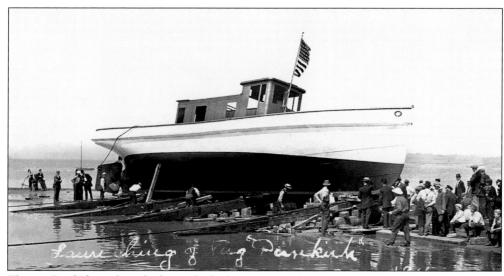

The tug *Dunkirk* was launched into the harbor in 1911. The Desmond Fish Company built it, the first steel boat to be made in Dunkirk. Like other tugs built on land, it had to be transported on wooden rollers from its building site to its launch location. (Robert Boehm.)

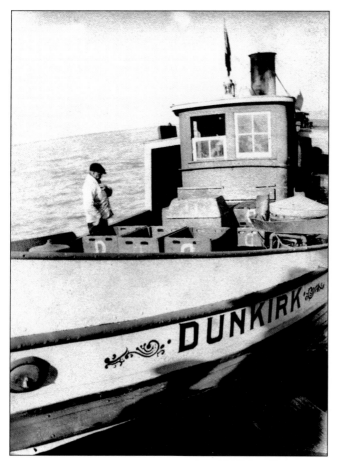

The *Dunkirk* stands ready to leave the dock, its fish boxes waiting to be filled. Various fish houses operated in the city, two controlled by the Desmond brothers, one by A. Booth and Company, and another by the Alexander Fish Company. Fred Helwig Sr., Theodore Walters, and William Meisner operated tugs, as did the Lake City Fish Company and the E. Sweet Company.

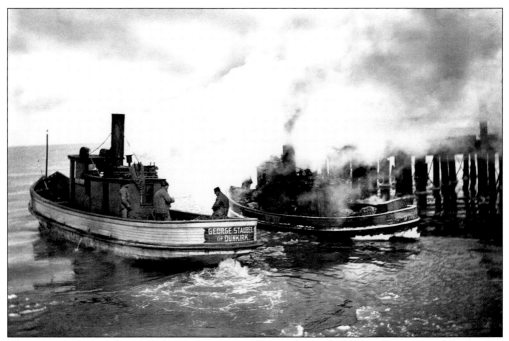

These boats departed to fish the waters around Dunkirk in 1905. They did so on a lake known for its unpredictable and fast-rising storms. In 1908, two tugs were held by ice off Point Gratiot for seven days. In December 1959, the 72-foot tug *Sachem* sank off Dunkirk, the cause never known. The entire crew of 12 died; when the vessel was later raised, it was completely intact.

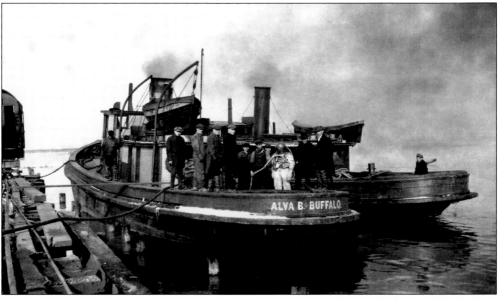

Work of all kinds was a constant part of life on the docks, including dredging of the harbor, rebuilding of the docks, and repairing boats and other equipment. Here the tug *Alva B.* out of Buffalo lies tied to the Central Avenue dock, readying a diver to go below to do repair work without bringing a boat to dry dock.

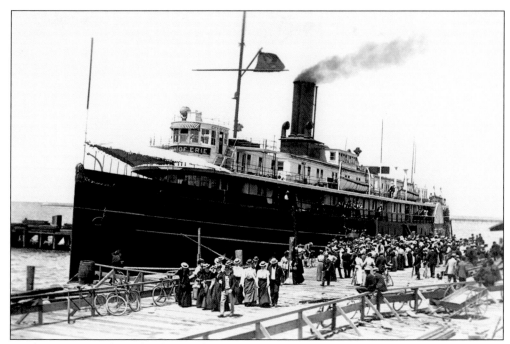

Sunday excursions brought the 300-foot *City of Erie* to the Central Avenue dock in 1890. It also stopped for layovers on journeys between Buffalo and Cleveland. The bustling scene here shows passengers disembarking, many to make railroad connections, some to stay at one of the 12 city hotels. Large steamers were used to maximize the number of passengers during a limited sailing season.

The pulpwood business was part of the Dunkirk harbor shipping trade until about 1939, when the weakened industry stopped abruptly after a strike. Ships as large as the 450-foot freighter *Fitzgerald* docked to unload pulpwood from Manitoulin Island in Canada's Georgian Bay. Loads were taken by rail to the Johnsonburg, Pennsylvania, paper plant. Three shifts might be required to offload a cargo right onto the gondola cars that sat on the Central Avenue dock rails.

The coming of the New York and Erie Railroad in 1851 resulted in it constructing a wooden wharf with a track and a grain elevator. City leaders and the public voiced complaints about continued decay of the rotting wood as the years passed. In 1915, the board of trade provided $100,000 toward replacing it. The first bucketful of earth is dumped here to begin the replacement project. To the left, the Nelson Opera House looms.

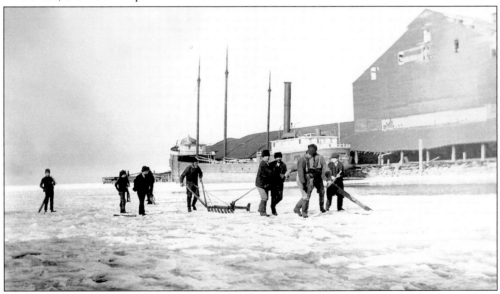

Men using axes and long-handled saws cut 100-pound blocks of ice from the frozen harbor and floated the cakes to a conveyor that extended 500 feet into the lake and spanned Lake Shore Drive, carrying the ice into the warehouse. It held a capacity of 12,000 tons of ice that could be filled in one week by 800 men, who stacked it and covered it in straw. This 1880 scene also shows the grain elevator.

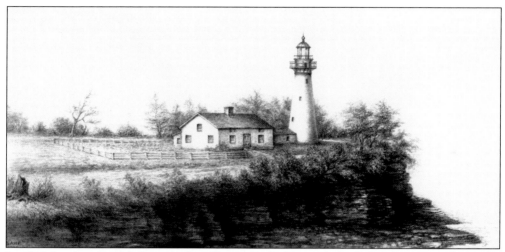

In 1865, local artist and photographer George A. H. Eggers created this drawing of Dunkirk's first lighthouse and keeper's cottage. Built in 1827 on the bluffs of Point Gratiot on land donated by Walter Smith, it was made of bricks made by Sampson Alton from clay from the lagoon nearby. Its first lantern was made by blacksmith Adam Fink.

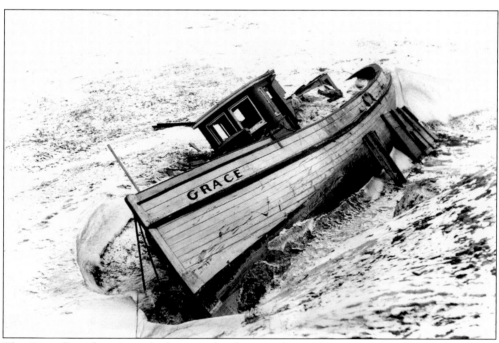

The *Grace* lies where it washed up on the shore, embraced by winter's ice. Rapid changes in weather and treacherous navigational hazards all contributed to a great many wrecks over the years, including the *Erie, Dean Richmond, Golden Fleece, Passaic,* and *Idaho,* all sunk near Dunkirk. The *Grace* was renowned for coming into harbor with 100 large sturgeon. After one escaped, the rest weighed in at 9,900 pounds.

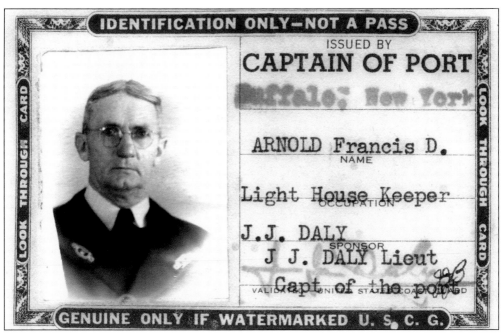

IDENTIFICATION ONLY—NOT A PASS

ISSUED BY
CAPTAIN OF PORT
Buffalo, New York

ARNOLD Francis D.
NAME

Light House Keeper
OCCUPATION

J.J. DALY
SPONSOR

J J. DALY Lieut
Capt of the port

VALID... UNITED STATES COAST GUARD

LOOK THROUGH CARD

LOOK THROUGH CARD

GENUINE ONLY IF WATERMARKED U. S. C. G.

After Walter Smith hired the first light keeper, the federal government hired others, starting with Abraham Day and including John Cassidy in 1845, Henry Severance in 1861, and Peter Dempsey in 1889. Francis Arnold served as assistant and then keeper from 1908 to 1950, while William Gannon was the last of the lighthouse keepers, serving from 1950 to 1958. He noted in a 1955 article how he cleaned the lens once a week by climbing the 61-foot tower. (Dunkirk Historical Lighthouse and Veterans Park Museum.)

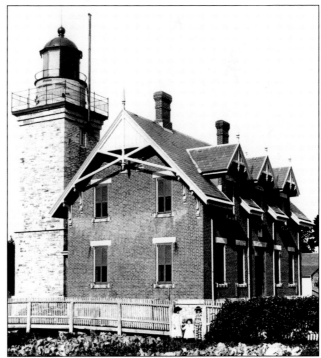

Imagine growing up in a lighthouse. These three children of one light keeper did so in the edifice built to replace the original lighthouse. Its 61-foot square tower replaced the old cylindrical one, thus matching the new Victorian Gothic–style keeper's house. Built in 1875 and fitted with a $10,000 Fresnel lens, it was added to the National Register of Historic Places in 1979. (Dunkirk Historical Lighthouse and Veterans Park Museum.)

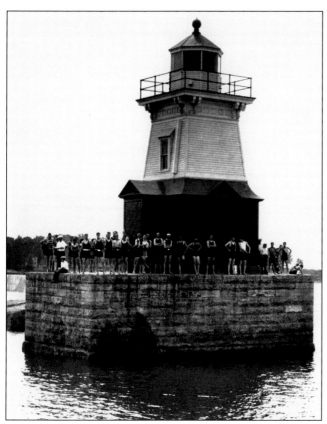

Officials erected the peninsular wall lighthouse on the breakwall at the mouth of the harbor itself to guide ships. Destroyed by ice in 1857, it was replaced by the structure pictured here, also wooden. Brave teens, such as these in the 1920s, used it as a convenient diving board during hot summer months. The beacon was removed in 1939 and replaced with an automated, skeletal tower.

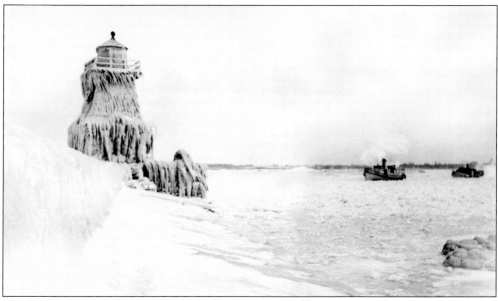

The light keepers had to maintain the beacon light, walking the narrow ledge to it twice a day for cleaning and lighting of the lamp. One keeper's wife would watch from the main light's tower with a telescope as her husband navigated the treacherous path, daring high waves and icy conditions. Fishing tugs attempt to plow their way through the ice in the harbor.

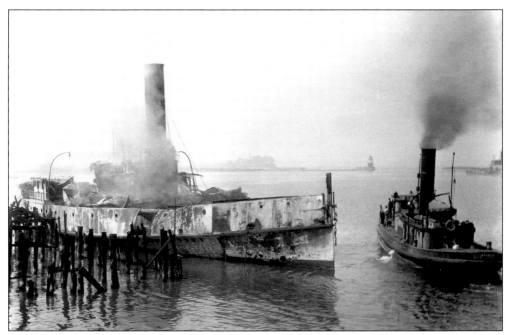

In 1925, the steamer *Colonial* caught fire and burned off nearby Barcelona. It is pictured here under control of the tugboat *Columbia* in the Dunkirk harbor, the beacon light visible in the distance. It was later dismantled at Dunkirk.

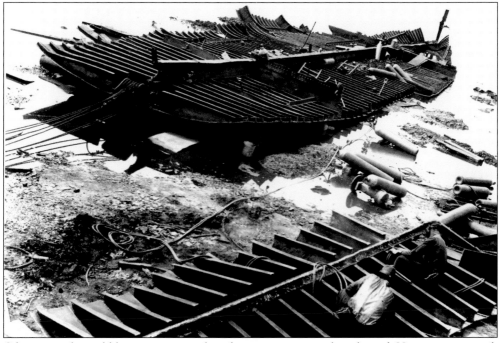

Often a wreck would lie at its resting place for years waiting to be salvaged. Here two men work in 1933 on breaking up the remains of the excursion steamer *Colonial*. It burned in 1925 on its way from Erie to Dunkirk. Although 29 were rescued, 2 drowned.

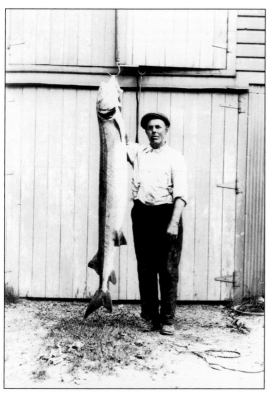

The caption on this 1933 photograph simply reads "250 pound sturgeon." Records show about 129 fishing boats still operating out of the Dunkirk harbor up to 1937; then the industry collapsed, overfishing and pollution as probable causes.

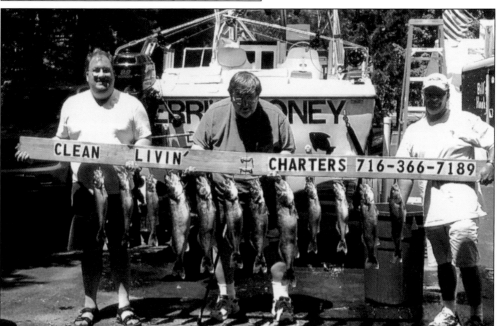

Today New York State boasts a $1.2 billion sport fishing industry. Bill Begier, center, operates his Clean Livin' Charters with his sons, here showing off a fine catch of 12 walleyes. His is one of many charters that work out of the Chadwick Bay Marina at the Dunkirk harbor in search of steelhead and walleye. (Bill Begier.)

Five

LIFE IN THE CITY

Numerous pictures in the archives of the Dunkirk Historical Museum show bustling scenes, streets lined with individual establishments, and proprietors and their assistants standing outside storefronts filled with goods.

The proprietors and workers that fill the photographs reflect the financial success and failures that occurred in Dunkirk's commerce, the immigrant movement that provided workers, and the changing role of women in society. The Irish Catholics and Russian Jews, the Polish and the Italians, all came to Dunkirk with their hopes and skills and found their place in the fabric of a city.

Proof of the harbor's continued importance was the establishment of businesses along Lake Shore Drive between the 1820s and the 1850s. These took advantage of the traffic from passenger and freight boats. At some point, the trend of development turned south along Center Street, now Central Avenue, which ran perpendicular to the harbor. The commercial district grew, and with the arrival of the first rail line in 1851, hotels and other businesses filled in along Third Street, Main Street, and the blocks surrounding Union Square.

Early structures were made of wood, but as the town expanded, brick edifices replaced them. This was often precipitated by fires, especially after the worst in February 1868, when a wind-fed fire destroyed nearly the entire business district, 38 buildings. The brick structures that followed rose two or three stories to provide their owners more profit. The fires also instigated an effort by municipal officials to establish a waterworks system in the form of 20 miles of water mains and hydrants. Fire companies formed in the wards, the police department strengthened, and dusty streets that turned to mud in winter were paved starting in 1891.

The city prospered; its commercial heart beat vigorously. In 1938, the chamber of commerce sponsored three days of Common Sense Sale Days to promote its many stores. As a testament to the vitality of its business base, 70 individual stores participated. Today only one of those survives, H. C. Ehlers.

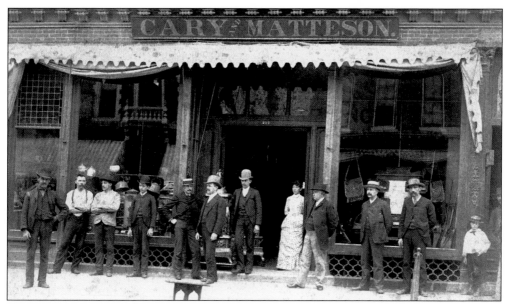

Turnover in store ownership was not uncommon, evidenced by Bellows and Cary's first hardware store on this site in 1861 becoming Cary and Matteson, shown here in 1888. Bloss and Welner next purchased it, then Bloss owned it solely in 1896. A glimpse into the window shows rifles, fishermen's pouches, kettles, and pots. An advertisement promised "all the latest improvements and necessary articles" for the customer.

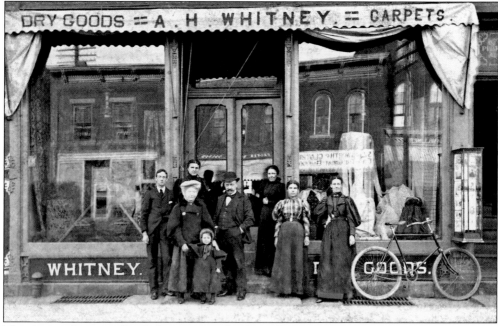

The dry goods store offered the customer books and magazines, carpets and draperies, ladies' and men's furnishing, and notions and household items. The A. H. Whitney store at 25 Center Street in 1897 shows A. H. Whitney and daughter Julia standing with cashier Nellie Timperly and clerks Matt Fitzer, Mamie Wade, Nellie Pugh, and Al Smith. Eight others such stores existed that same year.

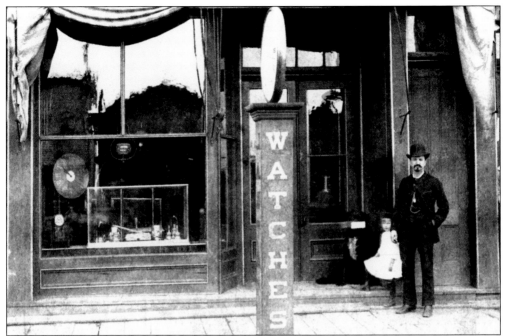

J. A. Stapf jeweler's shop arrived in the city in 1878 from Pennsylvania, and his successful business focused on the sale of watches, clocks, jewelry, silverware, "and the general requirements of a first class house." His son joined the shop in 1903, becoming John A. Stapf and Son. They bought their own building, and the business lasted until 1944.

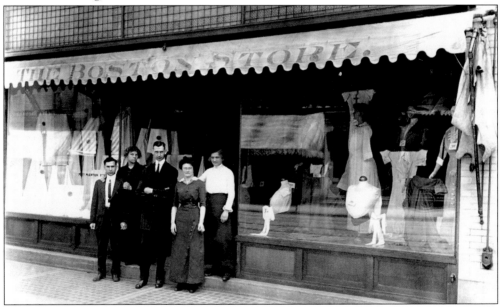

Jewish immigrants arriving in Dunkirk included tailor Jacob Ballotin and two brothers, who added to city commerce by opening the New York Store in 1907. It sold items from his Faultless Clothing factory in Buffalo. They then opened the Boston Store in 1911. His smart business practices and multilingual ability brought in large crowds, including Polish-speaking immigrants. Over 6,000 people attended opening day.

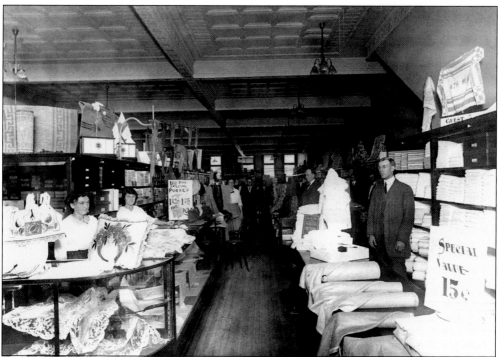

Sidey's became a city institution, starting in 1882 as the Buffalo Store under ownership of Scottish immigrants Thomas Whitson Sidey and John McLaren. Sidey observed in his diary that while he ran his business, 11 other clothing stores ceased existence in Dunkirk. Grandson Thomas W. Sidey III noted the store's motto was "service is the byword." Employee Fred Rosing, who would later open his own store, stands on the right.

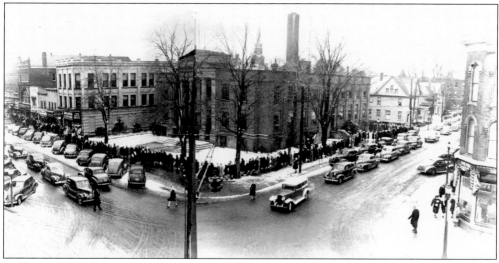

In 1946, a line of women wait outside Sidey's for a rare sale of 1,000 pairs of nylon stockings to begin. Thomas Whitson Sidey stated the principal that governed the store was "the best of goods at prices that return a reasonable profit." Sidey's epitomized family service as its three generations worked to serve three generations of customers. It survived for 111 years, closing in 1993.

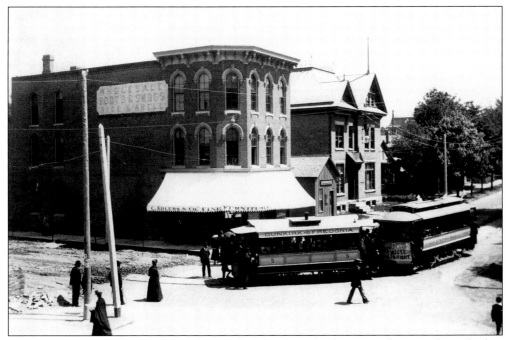

Tenacity allowed the H. C. Ehlers Company to be the only downtown business from the late 1800s to survive. German immigrant Charles Ehlers opened a dry goods store and funeral home in 1872, then sold furniture. Ehlers partnered with George Philippbar in 1882 and occupied the building shown here in 1892 on Central Avenue and Fourth Street, still occupied today. Ehlers's son Herman took over the business in 1910, and the building and name remain.

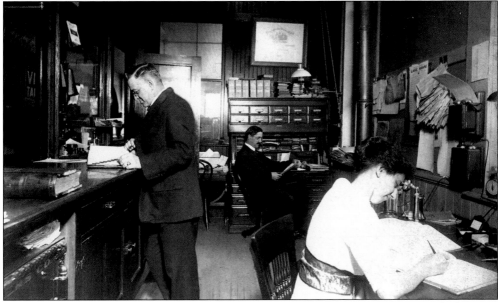

H. C. Ehlers Company office personnel complete paperwork in the early 1900s. The business manufactured specialized canvas curtains for the Brooks Locomotive Works and Mika curtains for cars and reupholstering. The H. C. Ehlers Company invented and marketed its own furniture polish invention, Lemoline, sold to this day.

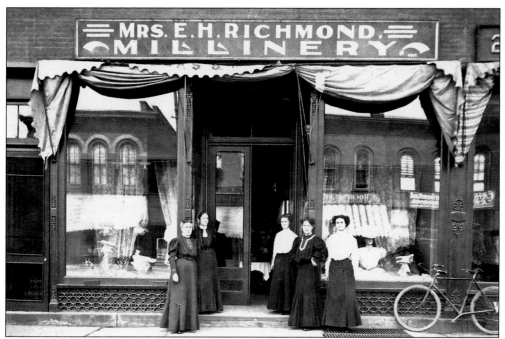

Women began to play different roles in the world of commerce by the beginning of the 20th century. Used to being limited to jobs as teachers, midwives, nurses, and domestics, women like Elizabeth Richmond ran their own businesses, here a millinery that started in 1887. Others ran specialty stores or they owned and operated boardinghouses and small hotels.

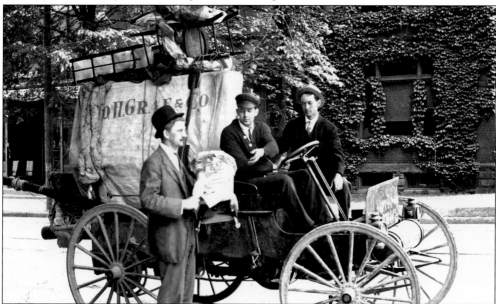

Geo. H. Graf and Company noted in a 1923 advertisement, "It is the knowledge of what an important part furniture plays in the making of happy homes that constantly inspires us to greater efforts." Known first as Graf and Lang in 1900, Geo. H. Graf and Company exemplified a business that kept up with the times, putting up its own building in 1907, remodeling in 1927, and again in 1935. The company stayed in the family until 1972. (Peter Reininga.)

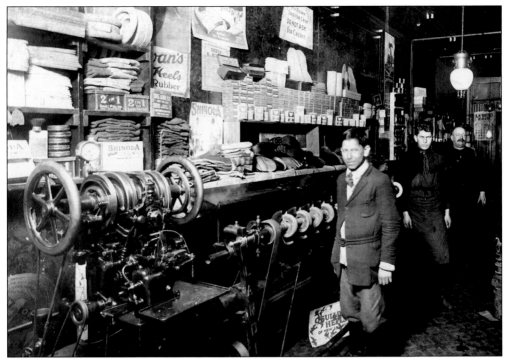

The first immigrants from Italy arrived in Dunkirk in 1888; cobbler Concezio Novelli and his family following in 1902 from Abruzzio. Having been a musician, chef, and cobbler in his native land, he opened a shoemaker's shop on Third Street, operating it until he died in 1932. His two sons, Dominic and Sandy, stand on his left and assisted him in the business.

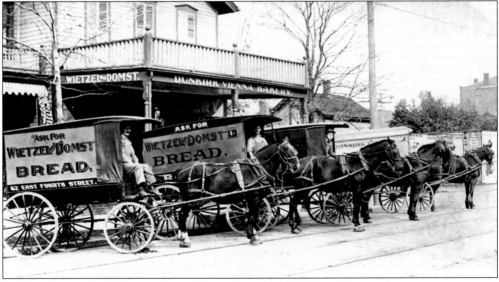

Use of horse-drawn wagons allowed many independent businesses to expand service to customers. The Wietzel-Domst Bakery, owned by immigrants from Germany, provided home and business delivery. It was said to "control a large trade throughout Chautauqua and Erie Counties," its popularity stemming from its "toothsome delicacies" and homemade breads and buns "free from all deleterious substance."

Even in 1958, two-thirds of the commercial farms in western New York State were dairy farms. The city's agricultural ties resulted in milk distribution businesses starting up. Bentley and Rencken's started in 1923, bought raw milk from farmers, pasteurized and later homogenized it, bottled it, and delivered it door to door. In the early days, delivery was twice a day, seven days a week.

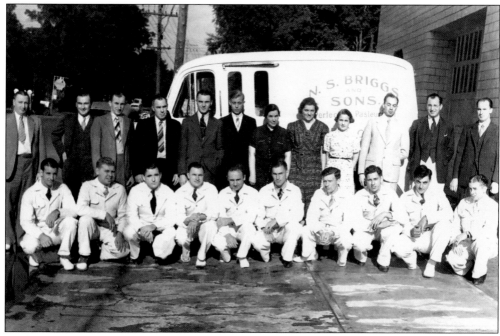

Noah Briggs began his dairy distribution business in 1906 on Middle Road. N. S. Briggs and Sons advertised "safe milk" that was properly pasteurized. It became the largest milk distributor in the county, processing 10,000 gallons a day.

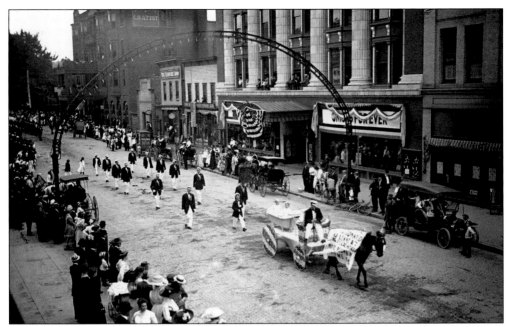

Electricity came to Dunkirk in 1886 when Brooks Locomotive Works employees set up a portable steam-driven dynamo that operated 16 carbon lights in Washington Park. In 1888, the city installed a dynamo at the water plant that provided power to arc streetlights. In 1897, steam-driven turbine generators provided lighting in businesses and homes. The streetlight arches shown here were erected in 1908, and they frame the city's change from bicycle and horse-drawn buggy to the automobile.

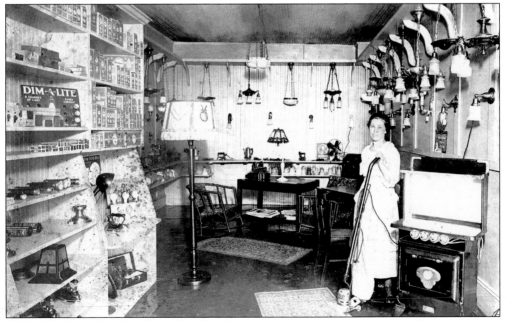

The store interior displays the multitude of lighting fixtures and other electrical devices available to the consumer in about 1910. The clerk displays a vacuum cleaner as various electrical appliances and lights line the walls.

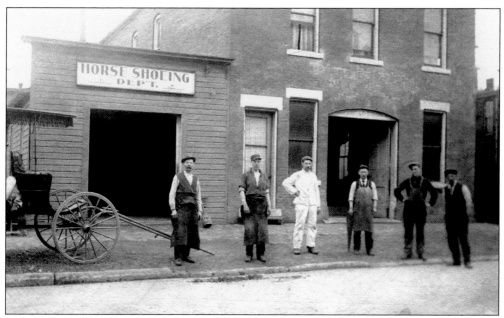

Dunkirk's earliest blacksmith, Adam Fink, started business in 1819, fashioning the first lantern for Dunkirk's lighthouse and creating the first steel-edged tool in the county. Frank Gruenberg, pictured here, ran a horseshoeing, welding, and painting shop on Second Street starting in 1896. Another smith, Lawrence Conklin, who operated a shop for 40 years on Central Avenue, made 150,000 horseshoes during his career.

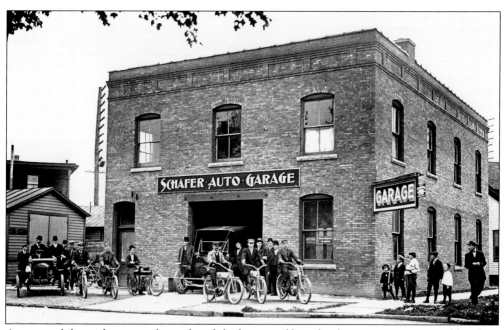

As automobiles and motorcycles replaced the horse and bicycle, the car repairman would replace the blacksmith. Brothers Henry and Charles, sitting in the Maxwell, opened Schafer Auto Garage on Lincoln and Wright Streets. The first in the city, it sold cars, tires, and motorcycles. Sundays would find motorcyclists gathering to set off for the countryside together.

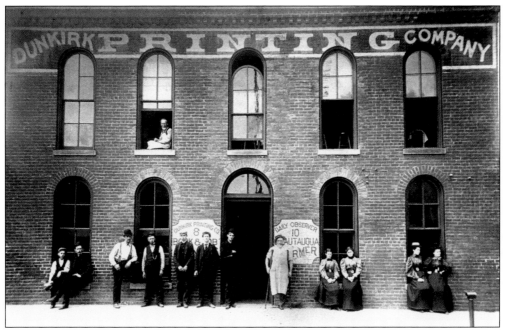

Between 1900 and 1910, the city had five newspapers, the dailies the *Dunkirk Evening Observer* and *Daily Herald* (ceasing in 1912) and the weeklies the *Grape Belt*, *Chautauqua Farmer*, and *Dunkirk Advertiser and Union*. The *Daily Herald* advertised it "contains all the latest News" at a cost of 10¢ a week. Employees stand outside the Dunkirk Printing Company in 1914.

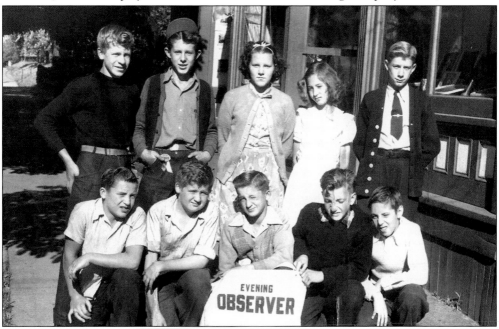

These newspaper carriers delivered the *Dunkirk Evening Observer* in 1946, a longtime tradition that continues to this day. A 1982 article cited 127 news carriers helping to deliver 14,000 copies of the *Dunkirk Evening Observer*. In that same year, H. Kirk Williams, great-grandson of the newspaper's founder, Dr. Julien T. Williams, served as editor. (Mrs. Joseph Woloszyn.)

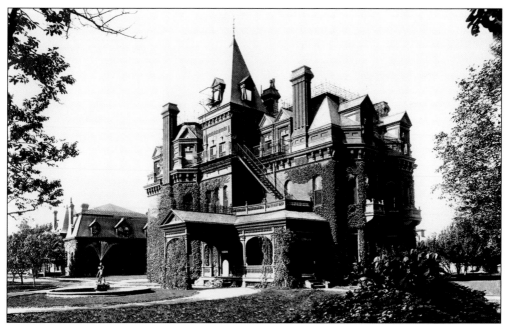

In 1898, Horatio Brooks's daughters offered the family mansion to the Young Men's Association to be made into a hospital and library in memory of their parents. The group, led by Charles Hequembourg, received state authority to incorporate Brooks Memorial Hospital. It served its first patient in 1899, a destitute man suffering from pneumonia. By 1930, the hospital had served 30,000 patients. In 1942, the edifice was torn down, and a modern building was erected.

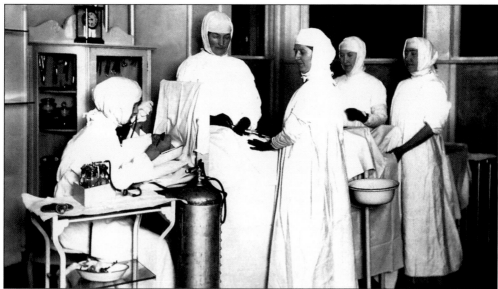

Nurses prepare a patient for surgery in the operating room at Brooks Memorial Hospital around 1910. A two-year nursing school started there in 1901; 12 students graduated in 1916. Ruth Walter Mohney wrote of her mother's on-the-job training as a nurse, explaining that in 1918, her mother "took classes, tended patients, scrubbed floors, washed and hung laundry in the basement of the former mansion, and studied." Starting salary was $7 a month. The school discontinued in 1924.

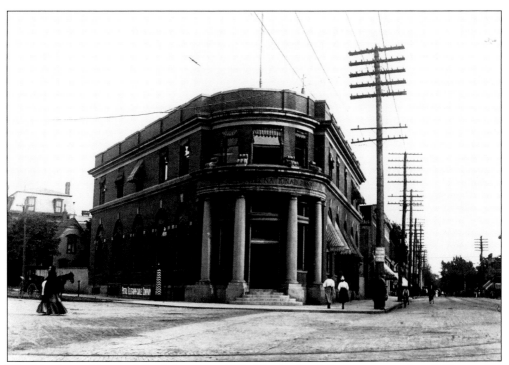

The Merchants National Bank began in 1882. The bank edifice, constructed in 1905, stood at the edge of and helped define Dunkirk's Union Square. Passengers would disembark from trains at the depot and find access to the Main Street commercial district. A robbery of the bank in 1935 by five men who took $20,886 was never solved.

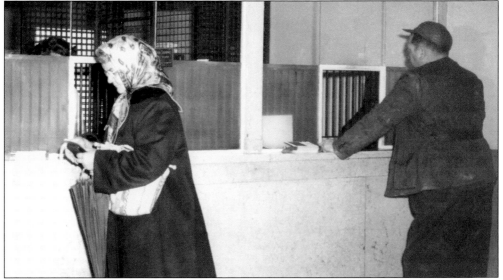

The Lake Shore Savings and Loan organized in 1891 with Marshall L. Hinman as president. Its success to this day brought it to its present location on Fourth Street. The 1894 booklet *Dunkirk as It Is and Its Possibilities* stated its financial operations were such that "probably no city of its size can show so many homes owned by the working people." Here customers stand at the teller window to carry out their transactions in the 1940s. (Lake Shore Savings Bank.)

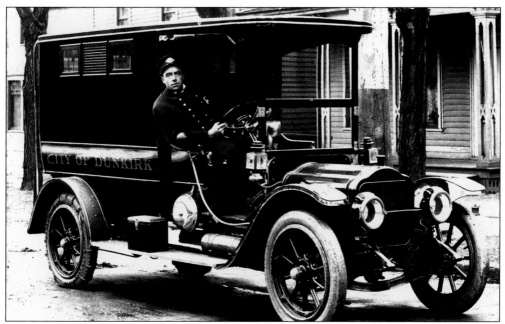

Policeman Frank Honert drove the Dunkirk Police Department's paddy wagon in 1912. Dunkirk's Mulholland plant built the vehicle's body, which doubled as an ambulance. First serviced by constables and village watchmen, the police handled the murder of a Civil War soldier in 1864, vandalism, thievery, gambling, and racing buggies in 1908, and cars violating the speed limit of 15 miles per hour in 1913. The first police force was appointed in 1880.

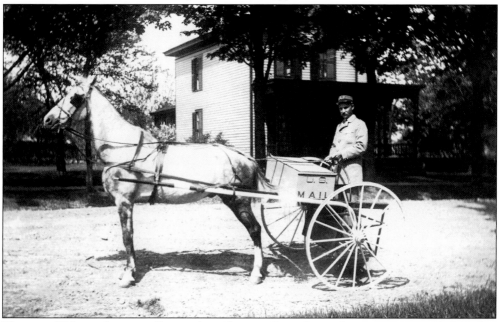

The year 1818 saw the post office in the village on Front Street, but it was not until 1887 that a carrier system was established, at which point, the post office changed location to the Nelson Opera House, and later to the Stearns Building, where it was open even on Sundays until 1911. Here postmaster Michael Mazany gets ready for delivery with the new postal wagon in 1891.

By 1852, O. Monroe had begun his daguerreotype gallery business in the city. In 1889, three photographers were located in the city, including George Eggers, Good's Studio, and Gifford's Art Gallery. These post office workers posed for Gifford's Art Gallery. Hand painting and retouching was employed, and photographs were produced in a variety of forms, including postcards and the view card format.

The composition and lighting techniques revealed in early photographers' work is evident in that done by Eggers, who operated a photographic studio on Swan Street. He and Dr. George Blackham, an avid amateur photographer, created a collection of photographs depicting life in Dunkirk.

An 1856 fire destroyed a block of the business district; an 1857 fire gutted the Loder House; and an 1868 fire destroyed 30 buildings. Fire response methods changed from a bucket brigade to hand pumps and later to 10 miles of pipe and the Holly Hydrant System in 1871. Here the running team of hose No. 4 poses in 1890.

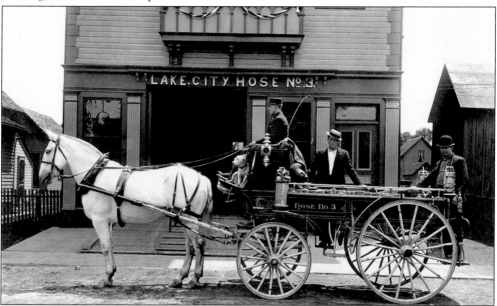

Hook and Ladder Company No. 1 and Engine Company No. 2 were established in 1853 as volunteer units. They used the "Loder Engine," a hand pumper supplied by the New York and Erie Railroad to protect its own shops. The village organized the Dunkirk Fire Department two years later. Horse-drawn apparatus arrived in 1899, with fireman Frank Miller being killed driving hose No. 1's rig in 1904 in a collision with a train. The department mechanized in 1912.

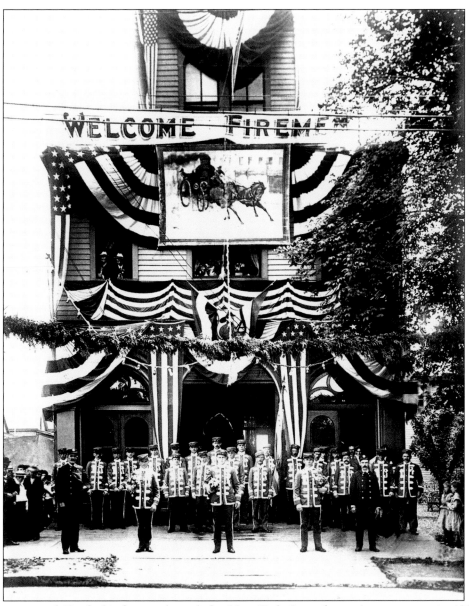

The city and Dunkirk's firemen hosted the New York State firemen's convention in 1904. The *Dunkirk Evening Observer* headline trumpeted that "Delegates Arrive on Every Train," resulting in the presence of 1,000 delegates from all parts of the state. They arrived to see the city's buildings covered with bunting and flags, such as is seen here at the Dunkirk Hose Company No. 1 building, and a large "triumphal arch" constructed on Central Avenue through which paraders marched. The delegates held meetings in the Nelson Opera House and held competitions at Central Park that gave out $2,500 in prizes. These included the "hub and hub race," finest-looking company, and hook and ladder race. Visiting bands gave concerts, and a "shore dinner" was served at Point Gratiot "large enough to feed the Japanese Army." The Erie Hotel housed many of the visitors and served as headquarters for state officials. At the end of the weeklong events, the firemen staged what has been called the greatest parade in the city's history, comprised of 60 units.

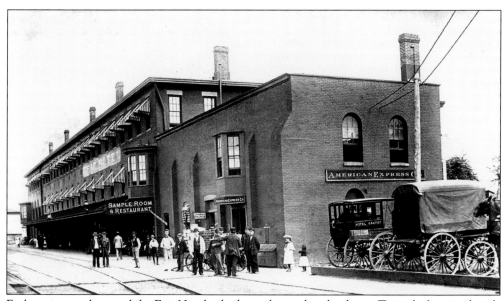

Early train travelers used the Erie Hotel, which was located at the depot. Typical of station hotels of the time, its horizontal structure ran the length of the train platform, with a baggage room, offices, sample rooms for salesmen, and dining areas. The outside was plain, but the inside made it "the biggest little hotel between New York City and San Francisco."

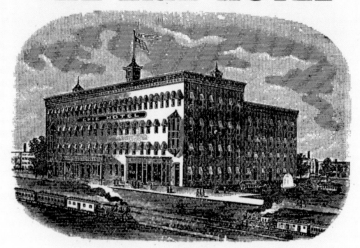

THE ERIE HOTEL

DUNKIRK'S BEST HOTEL.

JOHN J. MURPHY, Prop.

UNION DEPOT DUNKIRK, N. Y.

RATES $2.00 AND $2.50 PER DAY.

The Erie Hotel became a social and political center for the city and played host to Grover Cleveland, Theodore Roosevelt, Franklin Roosevelt (as vice presidential candidate), Sen. Robert Wagner, postmaster general James Farley, and Gov. Alfred E. Smith. It was nearly a century old when it burned in 1952.

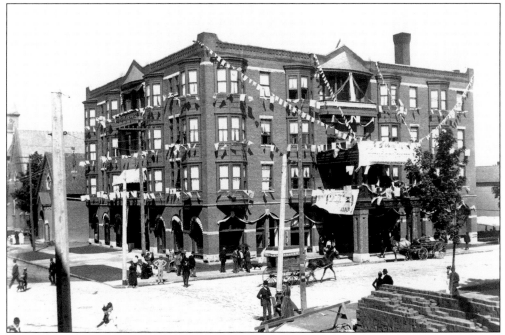

Twelve hotels of varying sizes existed in the city in 1894, including the Hotel Gratiot (later the Francis and then Dunkirk). Constructed under sponsorship of the Young Men's Association to spur more business, the four-story, 100-room hotel advertised it possessed a more favorable location "away from the noise of railroad trains." The hotel benefited from the Central Avenue streetcar stop and its own "bus," a carriage that carried customers from depot to hotel.

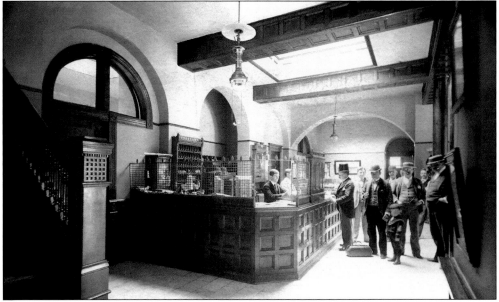

An 1894 advertisement for the interior of the Hotel Gratiot boasted a number of modern amenities, including elevator, local and long-distance telephone, telegraph office, reading room, café, barbershop, billiard room, news and cigar stands, lavatories, and commercial sample rooms. The office floor was made of white Georgia marble and the rooms supplied with steam heat.

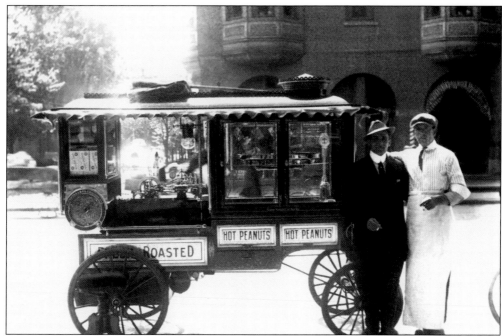

A sign on this cart reads, "Hot Peanuts." A vendor sold popcorn, Cracker Jack, and toffee kisses at any location with a crowd, here in front of the Hotel Gratiot around 1913. C. Cretors and Company of Chicago made the *Special*, the first large, horse-drawn popcorn wagon. It had a small steam engine with a toy clown that danced when the engine was in motion. In 1917, Savos Pazios would own a truck selling similar items, later operated by Louie Kostantino and then Paul Gestwicki.

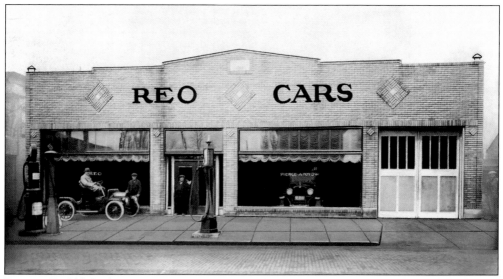

Ransom E. Olds built cars starting in 1905 in Michigan, including the Model B and Runabout. He would later launch the Oldsmobile Company. An advertisement in the 1925 *Kirwin's Directory for Dunkirk* states the Vaconti brothers sold "REO Cars and Trucks, Dunkirk Garage," as well as Pierce and Arrow vehicles, "steam heated and fireproof." The rock band took its name from the REO Speed Wagon, a light delivery truck the company produced.

Dunkirk's armory became its city hall in 1874, serving as military, civil, social, and political center. Its Romanesque-style entry arches and Italianate windows and cornices made it unique architecturally. The Civil War monument, now in Washington Park, stood at its entryway. An addition was used as a jail, and when the building burned in 1925, police and firemen battered a hole into the side of the building to free two prisoners.

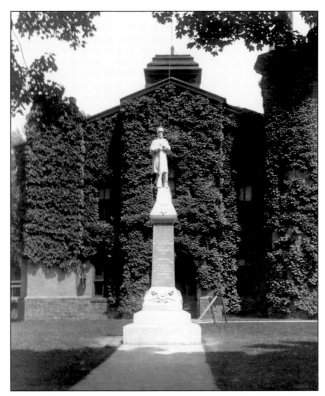

In 1880, at least seven coal companies operated in the city. Firms like H. H. Roberts , C. J. Alexander, and S. M. Hamilton supplied area customers with "anthracite, bituminous, Blossburg and Cannell coal, while coke and pig iron also command attention." Wood and stone products were often sold also. Paul Gestwicki's company offered "Domestic and Stoker Coal" even into the 1970s.

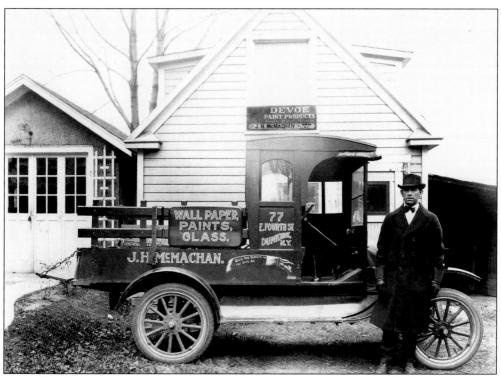

John McMachan arrived in Dunkirk from Ohio and began operating a small business out of his garage, handling wallpapering and painting jobs. He sold his Devoe Paint Products, still in existence, with the slogan "Save the Surface and You Save All." In time, he opened a store on Park and Fourth Streets, later operated by son Robert. (Robert Boehm.)

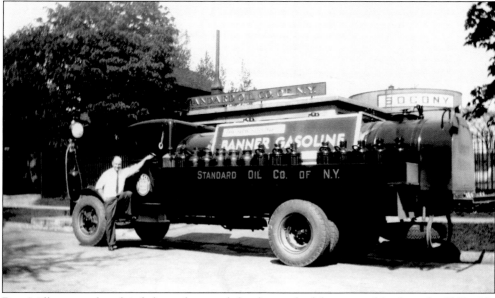

Don Milks remembers his father, who stands by the truck, delivering oil back in the 1920s. He worked for Standard Oil Company of New York, formed after the monopoly Standard Oil was broken up in 1911.

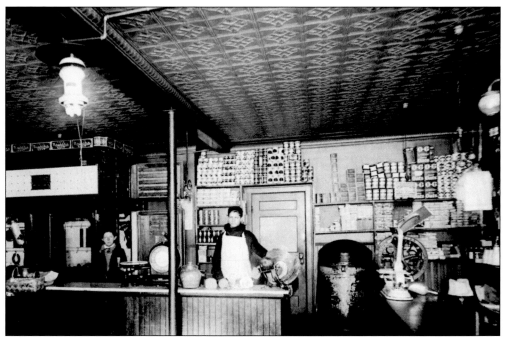

Frank Fafinski owned a meat market and corner store on Doughty Street for many years. Mom-and-pop grocery stores like his dotted neighborhoods and were a mainstay for residents. The 1951 *Kirwin's Directory for Dunkirk* lists 72 grocers, which included the larger stores Loblaws and A&P, but primarily corner stores like Fafinski's. In 1971, there were 41. (Frank and Patricia Levandoski.)

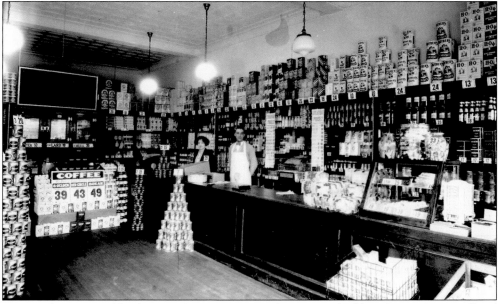

Mom-and-pop stores like the Patti Grocery Store on the corner of Fifth and Main Streets offered personal service, personal relationships with customers, and tradition. Establishments like Messina's and Valvo's, Valone's Meat Market, Tuczynski's, Marmurowicz's, and Incavo's survived in neighborhoods until competition from retail giants slowly closed them down.

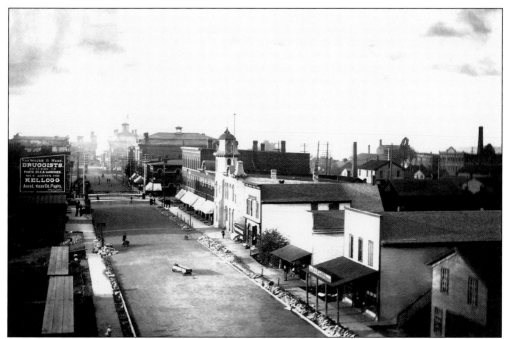

Newly bricked Central Avenue reveals several wooden structures on its east side around 1890. The fire headquarters with its circular tower was built in 1875. The lake would be just beyond the Nelson Opera House visible in the mist on the right side of the street. Additional bricks are being carried in a wagon and lie on the sides of the street.

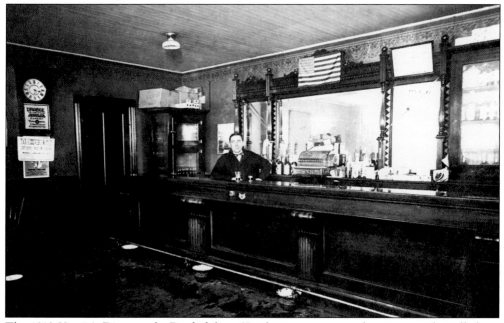

The 1912 *Kirwin's Directory for Dunkirk* lists 68 saloons, a quantity that suggests the rollicking nature of the town. Walt Hamernick operated a saloon on Third Street starting in the 1940s. Places like Gorka's, the Peanut Cafe, and the Hotel Francis are listed in the 1940 *Kirwin's Directory for Dunkirk* also. Note the foot railing and spittoons. (Frank and Patricia Levandoski.)

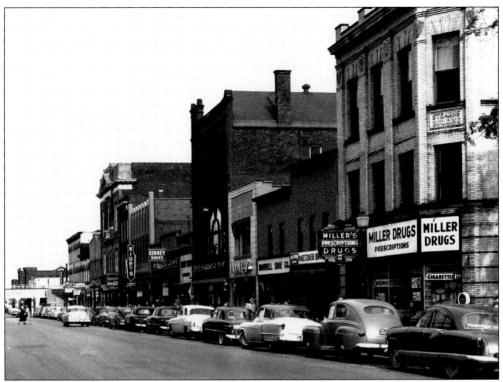

The year 1952 saw downtown Dunkirk busy with individual shops. The east side of "the Avenue" was lined with establishments like Candyland, Sidey's, Kenney Shoes, Naetzger's, Jayne's, and Miller's Drugs. Across the street at the Capitol Theater, *The Miracle of Fatima* was playing.

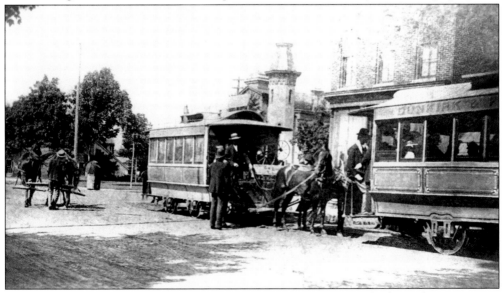

In 1864, the Dunkirk and Fredonia Street Railroad Company opened a horse-drawn streetcar system between the two villages, establishing the first trolley service in Chautauqua County. In 1891, the system was electrified. Here horse-drawn cars No. 8 and No. 9 stand on Central Avenue. The old city hall's tower is seen between the two cars.

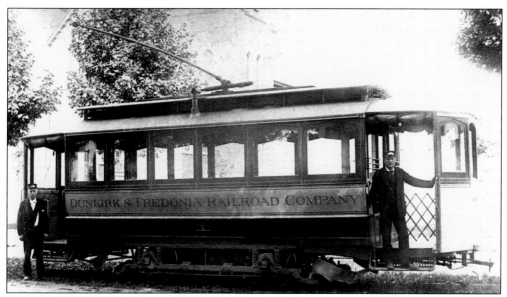

The Dunkirk and Fredonia Railroad Company's streetcar No. 1 stands ready for service. Convenience and comfort made trolleys popular, one-way single fares costing 10¢ and short-distance rides 5¢. A "Labor's ticket" sold for 6¢ and school ticket allowed one passenger unlimited rides for 10 weeks for $5. The 100-horsepower boiler used to fire the dynamo and motors to run the system were constructed by the Dunkirk Engineering Company.

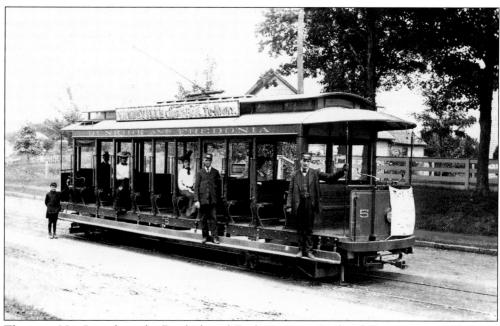

The open No. 5 car from the Dunkirk and Fredonia Street Railroad Company in 1903 shows its motorman Ralph Todd, right, and conductor John Fagan, left, preparing to move on after collecting passengers. Its sign announces "Vaudeville Central Park To-Night."

Six

CIVIC ORGANIZATIONS

"Let us not be weary of well-doing." This comment by Dr. George Blackham at ceremonies for the hospital's first nursing school graduation seem to have been adopted by the city of Dunkirk.

The city teemed with groups organized around some common cause, religious leaning, educational interest, ethnicity, or employment. Many were service based. The Masons, Elks, Kiwanis, Odd Fellows, the Loyal Order of the Moose, and the Lions all promoted assistance to their members and to others. The pamphlet *Dunkirk as It Is and Its Possibilities* of 1894 stated that 60 charitable, fraternal, and benevolent societies existed in the city. It would seem natural then that the city's longtime habit of promoting civic duty and giving assistance was first evident most clearly in 1886, when the Young Men's Association formed. It strived to exercise "unanimity of spirit" in assisting the city. The Young Men's Association sponsored lectures, concerts, and an annual fair to raise funds, all of which were used for civic improvements. They improved Washington Park, helped to create the hospital, the library, and the pavilion in Gratiot Park, and financed the building of the Hotel Gratiot.

Such civic mindedness culminated in the 1946 Dunkirk to Dunkerque and the 1947 Aid to Poland and Aid to Anzio drives. These activities provided at least $100,00 to each foreign city and brought fame to Dunkirk. Indeed the city did not tire of "well-doing."

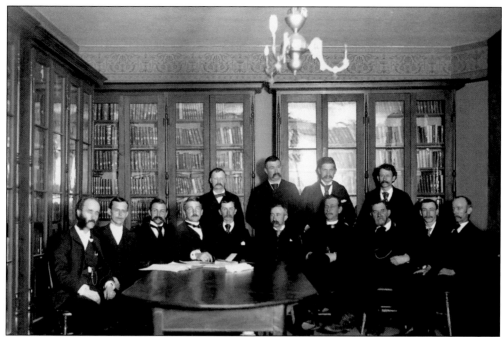

Finis coronat opus, or the End Crowns the Work, was chosen as its motto by the Young Men's Association. It formed in 1886 with the express purpose of serving as a philanthropic and civic-minded organization to aid "the material and intellectual welfare of Dunkirk" in order to make "permanent improvement in the city." It disbanded in 1912.

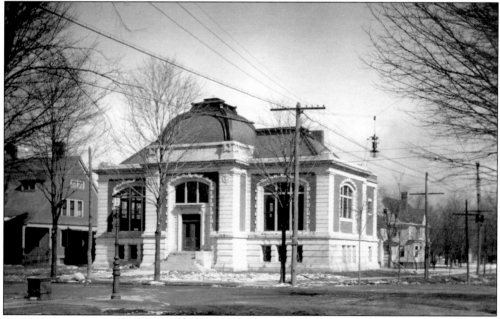

While only existing 26 years, the Young Men's Association accomplished much, playing a pivotal role in providing a hospital for the city and the Dunkirk Free Library. Its project was aided by funds from the Carnegie Foundation as well as from its fund drives. The library opened in 1904.

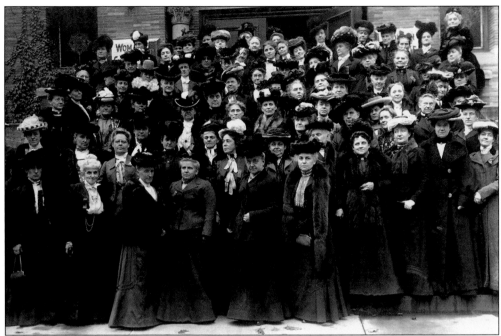

Dunkirk's women established the Women's Educational and Industrial Union in 1888 at the home of Mary Bookstaver, the mayor's wife, "to increase fellowship among women, to promote practical methods for securing their educational, industrial and social advancement." The 148 members raised funds for their own building, where for 30 years lectures were given on civic subjects, young women could take classes, poor women could receive financial aid, and women with legal problems could receive legal counsel through the Protective Committee.

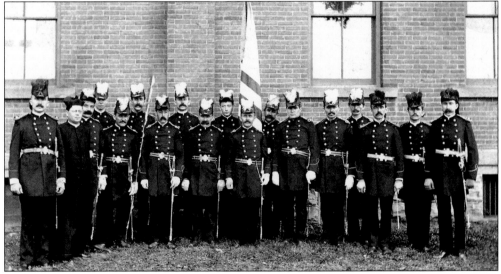

With an increasing Catholic population, a branch of the Knights of Columbus formed by 1904. A fraternal benefit society, it promoted fellowship among members and their families through educational, charitable, religious, and social works. It also provided financial aid to members and their families. After using the Bookstaver residence, it built its own building, continuing its work to this day.

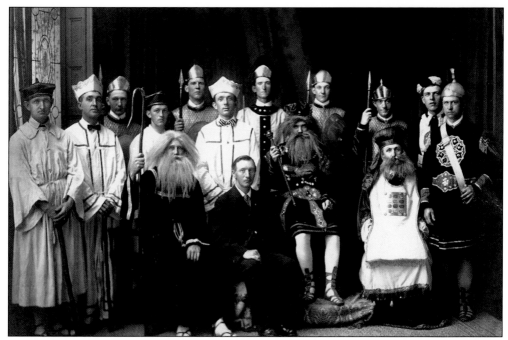

The Knights of the Maccabees acted as an insurance organization and fraternal group, which conferred three degrees: Degree of Protection, Degree of Friendship, and Degree of Loyalty. Individuals paid "tent dues" for a policy for death and sick benefits. The city's group was the Dunkirk Point Gratiot Tent No. 70, which met in its own hall and whose Initiation Team, as shown here in 1910, were ready for ceremonies of induction.

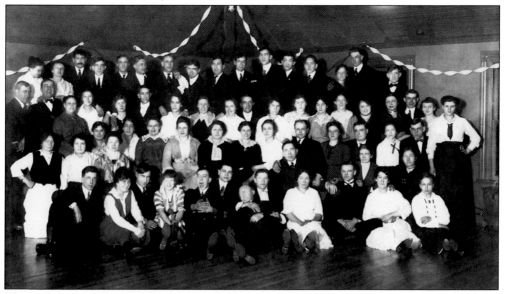

The Polish Businessmen's Association gathers together here for an indoor picnic. Polish immigrants came to western New York State for industrial jobs as early as 1848, becoming Dunkirk's largest ethnic group. Their closeness and desire to continue their cultural heritage was typified by formation of the First Ward Falcon Club, Fourth Ward Falcon Club, Moniuszko Club, Kosciuszko Club, and Dom Polski.

Polish immigrants settled in the First and Fourth Wards and then Polish national alliances met to raise money to purchase "the home," Dom Polski. The Polish Literary and Assembly Rooms Association, an organization for "gymnastic, dramatic, musical, and cultural activities," occupied its first structure in 1911, before building the present brick one. This cover page of its constitution is adorned with the white eagle, Poland's oldest national symbol.

KONSTYTUCYA

PRAWA I REGUŁY

STOW. DOMU POLSKIEGO

The Polish Literary and Assembly Rooms Ass'n

Zorganizowanego Dnia 28go Maja 1911 Roku

DUNKIRK, N. Y.

Drukiem Dziennika dla Wszystkich, 928 Broadway, Buffalo, N. Y.

In 1971, the Kosciuszko Club organized an effort chaired by Clem Lutz to pay tribute to Tadeusz Kosciuszko, "a Polish Son of Liberty" who came to America at the start of the American Revolution to assist George Washington. He was made general after fighting at Ticonderoga, Saratoga, and West Point. Three descendants of the general attended the ceremonies at the monument, erected in Kosciuszko Square off Lake Shore Drive.

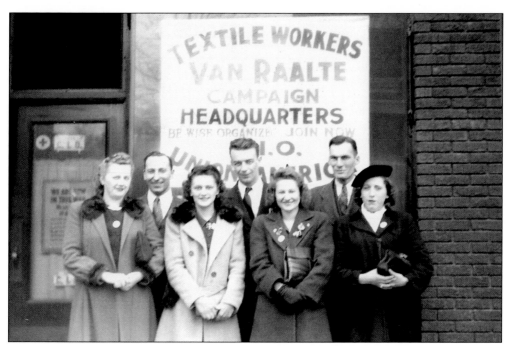

"Be wise, organize." These words are the rallying call on the sign behind these textile workers from the Van Raalte plant. The Congress of Industrial Organizations (CIO) attempted to unionize textile workers in the 1930s, here arranging meetings with employees. The union movement would strengthen over the years, improving worker pay and rights.

INTERNATIONAL UNION
OF THE
United Brewery Workmen of America.

International=Verband der Vereinigten Brauerei=Arbeiter von Amerika.

International Union No.	Local Union No.
15002	4

BOOK OF MEMBERSHIP.—Mitgliedsbuch.

Name: } *Herman Glen*

Where Born? Geburtsort: } *Dunkirk. N. Y.*

When? Geburtstag: } *June 1th 1878*

Initiated: Eingetreten am: } *February 23th 1899*

in L. U. No. } *16* Branch: } *# 1.*
in 2. U. No.

Locality: Ort: } *Dunkirk. N. Y.*

Adam Huebner
International Secretary-Treasurer.
Internationaler Sekretär-Schatzmeister.

Louis Kemper
International Corresponding Secretary.
Internationaler Korrespondierender-Sekretär.

Joseph Protetto
International Financial Secretary.
Internationaler Finanz-Sekretär.

In 1899, Herman Glen of Dunkirk was a member of the United Brewery Workmen of America. It was a union that was so tied to its German roots that its early proceedings and conventions, including contracts, were entirely in German, later in German and English. The name continued through 1912, but by 1917, the union called itself International Union of United Brewery and Soft Drink Workers of America.

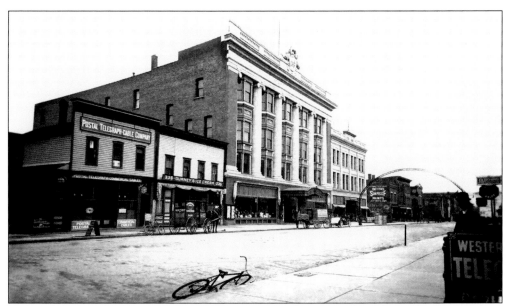

The Irondequoit Lodge formed in 1853 with 12 members and then constructed its own Masonic building on Central Avenue in 1908, one of the most splendid buildings in the city. The Masons became a focal point of business in the city since most of its prominent men joined. Based on the ideal of fellowship, members worked to promote good citizenship, integrity, and honesty.

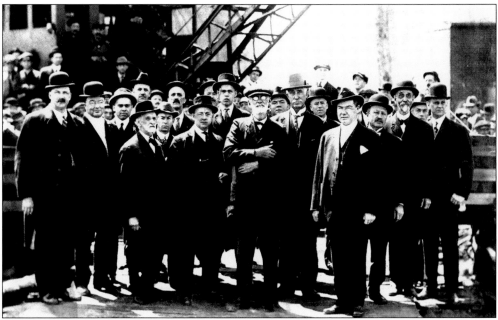

Board of trade members and city officials including Mayor John Sullivan and *Dunkirk Evening Observer* editor Gerald Williams gathered for the start of dock reconstruction in 1915. Dunkirk businessmen formed the Commercial Association of Dunkirk in 1887, followed by similar organizations like the Merchants' Exchange, board of commerce, board of trade, and chamber of commerce. Each espoused the similar "principle of organized cooperation to the development of their community."

In 1946, Dunkirk organizations, merchants, unions, and citizens led by Mayor Walter Murray as chairman banded together to raise over $100,000 in material aid for their war-devastated sister city, Dunkerque, France. So spectacular was the feat that the *Times Herald* of Washington stated, "It is a veritable tale of two cities. One of them famous and one of them that should be."

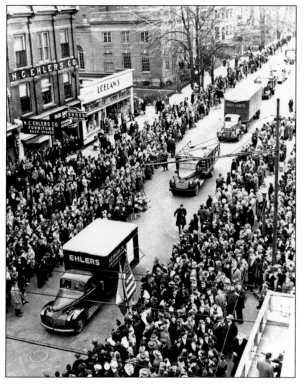

On Thanksgiving Day 1946, a mile-long parade passed a review stand displaying the donations being handed over to Dunkerque. Mayor LeMaire Robelet of Dunkerque, the ambassador of France Henri Bonnet, actor Charles Boyer, actress Simone Simon, CBS president William Paley, and other dignitaries witnessed livestock and farm equipment, an ambulance and medical supplies, tools and playground equipment, dental equipment, and school supplies pass by.

The Dunkirk to Dunkerque events brought national acclaim. CBS radio broadcast the events live. Eleanor Roosevelt praised the city in her column "My Day." The *New York Times*, *Newsweek*, and many other publications featured the story. Here national news photographers are joined by the *Dunkirk Evening Observer*'s Lamar Schnur, on right.

Dunkirk mayor Walter Murray, left, presented French ambassador Henri Bonnet a plaque forged in a Dunkirk foundry that read "For Life and Liberty, Dunkirk to Dunkerque." Mayor Murray was presented the Legion of Honor in recognition of the service Dunkirk had rendered to Dunkerque.

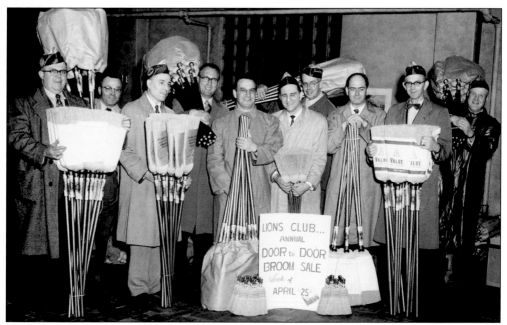

The Dunkirk-Fredonia Lions Club incorporated in 1941, its sight conservation committee assisting the visually handicapped. The White Cane sales, broom sales, and food sales at the fair raised funds for high school seniors, St. Joseph's School (for the deaf), and the Girl Scouts camp. Indeed, "rewards have been not in receiving, but in doing." Blind city court judge August Jankowski stands behind the sign. (Dunkirk-Fredonia Lions Club/John Banach.)

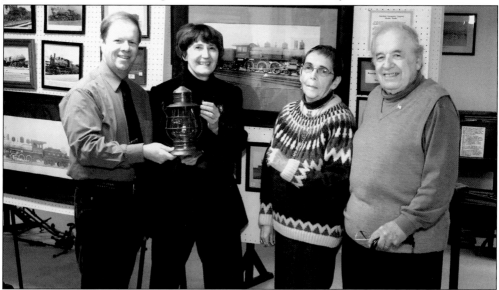

Author Diane Andrasik examines a lantern with Historical Society of Dunkirk president Roy Davis, far left; vice president Pat Rosing, second from right; and city historian Robert Harris, far right. The society organized in 1973, receiving its permanent charter from the board of regents, New York State Education Department, in 1977, led then by president Louis Van Wey. The society has held educational programs, erected the railroad memorial, and preserved the King Neptune statue and historical records and photographs. (Photograph by Pamela Arnold.)

Seven

LEISURE AND THE ARTS

Recreation for many of the earliest community residents was severely limited by the requirements of living and work. But once the workweek and workday began to shorten, and more people in the community had time and money, recreational activities rose in importance. Involvement in the arts became the focus of many.

Activities centered especially on the lake, sports, and music, all present to some degree from about the 1860s on. *Dunkirk as It Is and Its Possibilities* delineated the advantages of the lake, extolling its "beautiful, semicircular bay" and its "graceful shore line." Point Gratiot was described as being "a favorite resort in summer, offering cool and inviting resting places, sequestered nooks and shady paths and drives beneath grand old forest trees." It was pointed out that in looking out at the lake, one could see "something of the grandeur of the ocean." So many activities revolved around the lake. Point Gratiot, Hickoryhurst, Harrysbourg, and Van Buren Bay became popular destinations for many.

Sporting activities quickly became favored. Baseball flourished first, with teams such as the Lake Views, the Belmonts, the Alerts, and the Polish Nationals forming. Football took hold in the late 1800s, mostly linked with the high school. The school would have its first gymnasium in 1908, and interest in track, basketball, and other events would increase. The city had a bowling alley as early as 1906, and the Dunkirk Cycle Club grew to 100 members.

The Nelson Opera House hosted vaudeville and operatic singers. Silent movies captured the people's imaginations. Harness racing, the arrival of the circus, and the many activities at the Chautauqua County Fair entertained residents.

Lastly music played a vital role in the lives of people. Singing societies formed around ethnic and religious lines, and bands attracted crowds to the pavilion and to the social halls. Membership in drum corps swelled, and their presence enlivened city parades.

By 1857, German immigrants in the city numbered about 1,100 people. The Germania Gesang Verein, or German Singing Society, was organized in 1856. This 1858 photograph presents many of the prominent citizens of German background. The group kept contact with its homeland, raising funds for flood victims on the Rhine River in 1856. Julius Mayer was president and A. Richter was director.

The existence of several music-based groups in the latter half of the 19th century emphasized the desire for people to participate in the arts. These included the Ladies Mandolin Orchestra of Dunkirk, the Dunkirk Choral Union (organized in 1868), the Dunkirk Music Club (organized in 1893), and the Dunkirk Orchestra of 1919. A number of music teachers advertised their services in the local index, along with stores that supplied instruments.

The Rizz Razz Harmony Boys reflected the explosion of musical forms that swept the country at the beginning of the 20th century. Made up of Bill Barnes, Charlie Siragusa, Tony Pagano, Bill Ebert, Harold Fout, and George Harris, the young men strike a stylish pose in Good's Studio for this 1921 portrait.

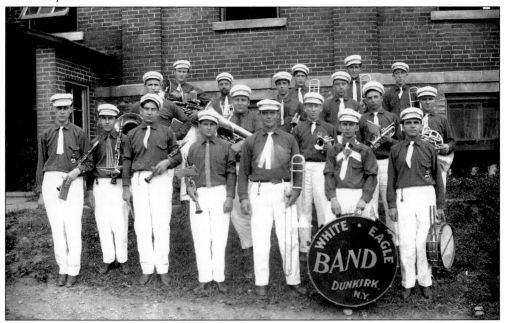

The White Eagle Band formed in 1904, one of many that included the Atlas Crucible Steel Company Band in 1920 and the Gestwicki Orchestra in 1918. Each revealed the enthusiasm that the generation had for the desire to entertain and be entertained and especially for its love of music.

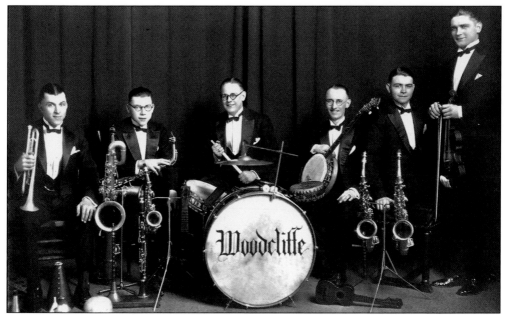

The Chet Kane Band, Polka Dots, and Akbar Band all played the parks and the pavilion, social clubs, and the county fair. None lasted longer than Woodcliffe, which played 50 years, the longest continuing orchestra in the country. It played 3,481 performances from 1924 to 1974. Named after the woods and cliffs of Point Gratiot Park, with an *e* added "for class," it played its first gig at the Erie Hotel.

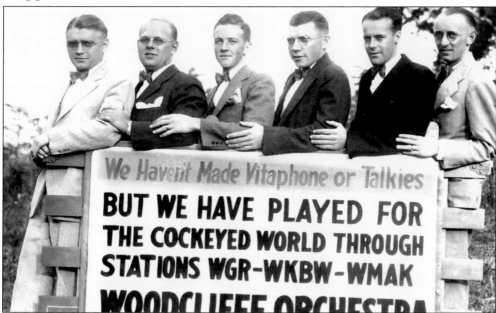

Woodcliffe played with 5 to 10 men, here including, from left to right, leader Tony Strychalski, manager Hank Ebert, Tom Ambrose, saxaphonist Joe Gestwicki, Ed Harris, and arranger Bill Ebert. They turned down the Music Corporation of America's offer to tour but did so for a chamber of commerce goodwill tour of Chautauqua County and Pennsylvania in 1930. They traveled with their piano strapped to a flatbed truck from which they played at each stop.

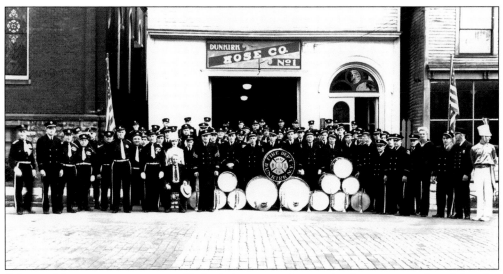

A host of drum corps groups provided stirring entertainment in the many parades of the city. These included the St. Stephen's Militia Drum and Bugle Corps, the Knights of St. John Drum and Bugle Corps, the American Legion Drum and Bugle Corps, the Dunkirk Hose Company No. 1 Drum and Bugle Company, and the Murraymen of Murray Hose Company No. 4. The brass, percussion, and color guard created its essence.

Mary E. Spera advertised in *Kirwin's Directory for Dunkirk* as a dancing teacher in 1910, about the time this young lady, Ruth Hilton Klopfer, would have taken lessons. Dance studios offered those with a flair for performance a chance to take part in the performing arts. Louise Heyl would offer dance lessons at her Heyl Dancing Studio for 50 years, starting in 1925. (Janet B. Klopfer.)

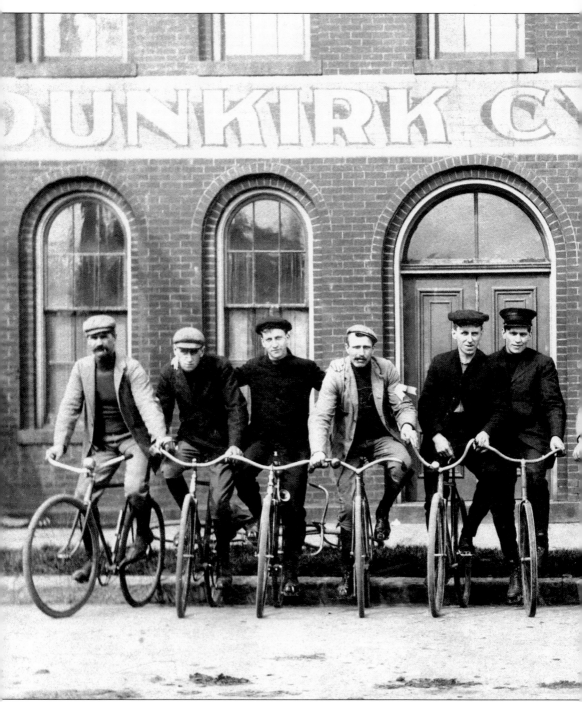

The U.S. Census Bureau estimated that factories built 1.2 million bicycles in 1899, a testament to their popularity once the more easily ridden "safety bicycle" was developed. It offered greater mobility compared to the older-style "ordinary" bicycle with its high front wheel. Cycle clubs, such as the Dunkirk Cycle Club, shown here in 1890, spread throughout America, holding

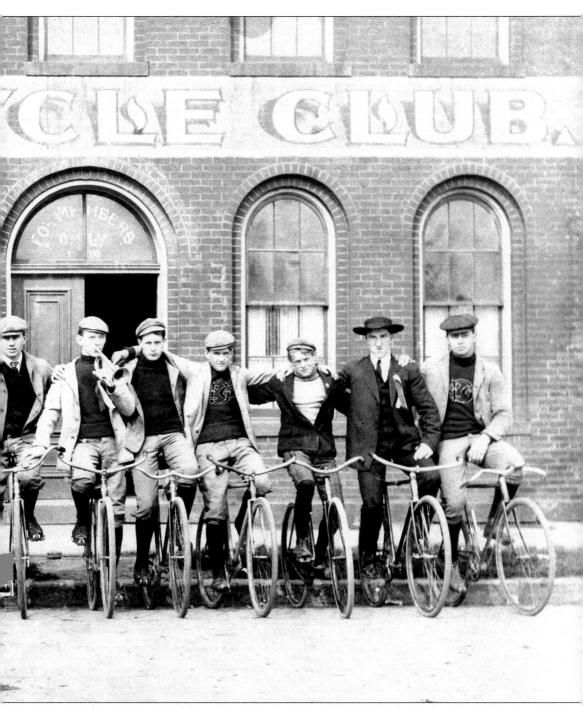

countryside excursions and bicycle races. Historian Leslie F. Chard noted a Central Avenue resident observed 497 bicycles pass his house as he sat on his porch one evening in 1898. The Dunkirk Cycle Club's membership reached 100, but the bicycle boom waned, and the club disbanded in 1921, victim to the new mode of transportation, the automobile.

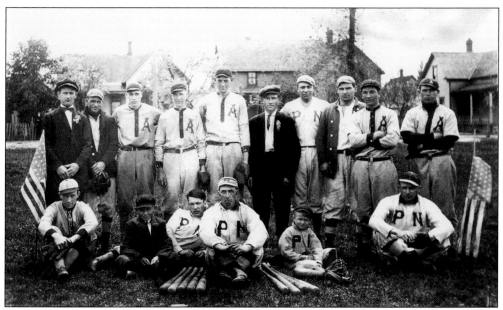

Asked the reason for baseball's popularity in Dunkirk, former player Jim Robertson explained, "For street kids trapped in the midst of chaotic, sprawling industry, it could be an escape." In the 1920s and 1930s, Dunkirk teams played Jamestown and Buffalo teams and exhibitions with the Buffalo Bisons, Pittsburgh Pirates, Havana Cubans, and Homestead Greys of the old Negro League. Standout player Carl Hoeppner (on ground, left) coached at Dunkirk High School for many years.

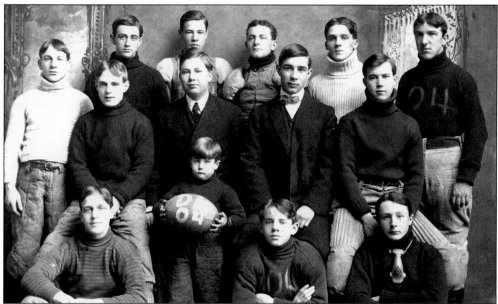

This 1904 football team would advance the ball 5 yards in three attempts, but in two more years that would change to 10 yards. As early as 1901, Dunkirk's school system began organized teams such as football in response to greater interest in more varied sports and the need for greater control of their management. The physical training law of 1916 would cause an even greater interest in furthering physical health of students.

As other sport pursuits gained popularity, Dunkirk established two country clubs; Willowbrook opened its clubhouse and 35 acres in 1901, on the shore of Gerrans Pond. An annual $10 fee gave access to a nine-hole golf course with the pond as one of the hazards golfers faced. A bridge led to a tee from which golfers had to drive. The pond served as a skating rink in winter.

The building of Shorewood Country Club in 1918 caused the decline of Willowbrook. The newer club had an 18-hole course, which opened two years after the clubhouse was finished. Situated right on Lake Erie, it presently offers 6,757 yards of golf and boasts that only two rounds of golf have been recorded as having been played under its par 72.

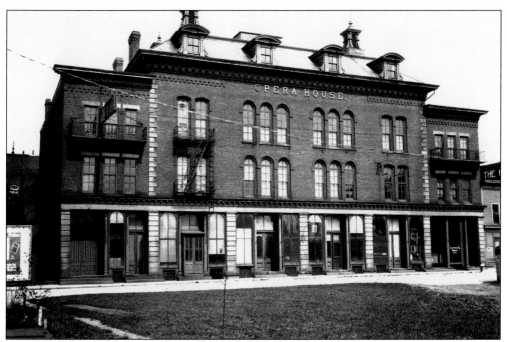

Dunkirk merchant Nelson Bartholomew built the brick opera house in 1867 on Center Street, and after its purchase by Joseph Nelson, it became the Nelson Opera House. Theatrical shows bound for Chicago used the Nelson Opera House as a tryout place before going on to Chicago. Ray Bolger, Tom Mix, and Harry Houdini played there as well.

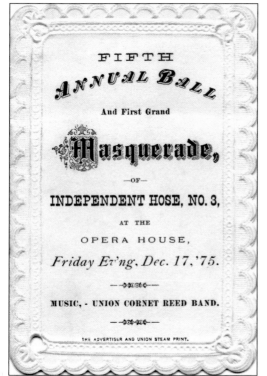

The 1,000-seat theater of the Nelson Opera House became the center for public events such as balls, graduations, and conventions. It hosted the 1875 firemen's masquerade and the 1904 state firemen's convention. At various times, its lower floors housed the YMCA, the post office, a grocery story, a jewelry business, and the Western Union Telegraph.

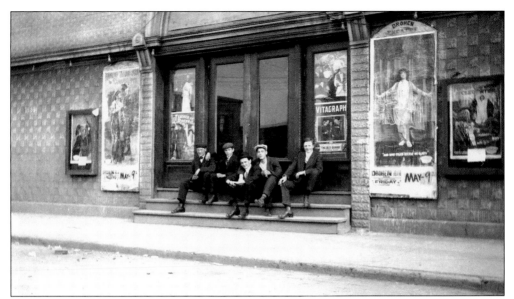

Owner J. L. Dronen opened the Bijou Theater, Dunkirk's first movie theater, in 1906 on Main Street, playing silent films like Charlie Chaplin's *The Tramp* for 5¢ admission. The Empire Theater, Drohen Theater (pictured here), Shadowland, and later the Capitol and Regent Theaters provided entertainment for a fascinated public. The Vitagraph advertised was an early moving picture production company.

City business recognized the importance of unity achieved through recreational events such as company picnics. These were often held annually, both indoors and out, along the shoreline or at favorite picnic spots. Feinen's and Werle's Grove were such places, along with Promenschenkle Pavilion, here the site for the Safe Store employees in 1914.

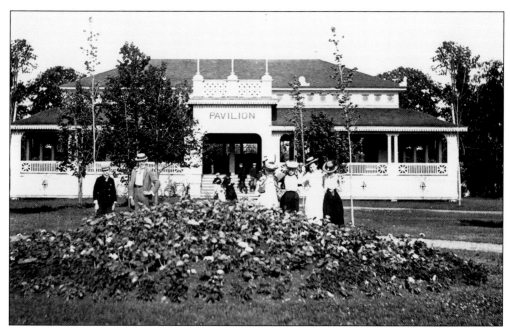

An 1839 lease between Russell Nevins and Dunkirk trustees designated land as a public park "for the benefit and pleasure of the inhabitants of the said Village of Dunkirk . . . for the term of 999 years." Rent was set at 1¢ per year. The park was named Point Gratiot, after Gen. Charles Gratiot, West Point engineer. After the pavilion was built there in 1899, it would not be uncommon for 2,000 to attend dances and concerts.

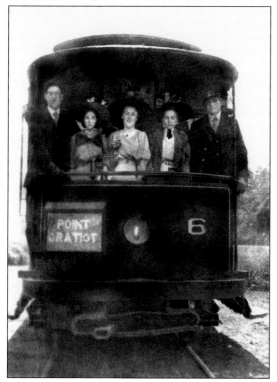

In 1900, H. C. Hequembourg and Daniel Toomey built the Dunkirk and Point Gratiot Traction Company line to Point Gratiot. In the summer, the line operated large open summer cars, and they would fill with people headed to the ball games, vaudeville shows, and concerts there. On July 4, 1901, the trolley recorded carrying 10,000 people to Point Gratiot. (Darwin Barker Historical Museum.)

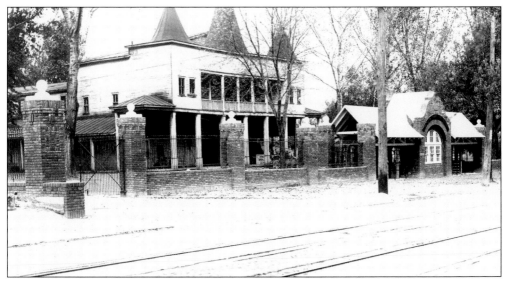

The Chautauqua County Fairground allowed county residents to focus on its agricultural nature. Organizers purchased land in 1859 to establish a permanent location for future fairs, first called Central Park. In 1900, the Chautauqua County Agricultural Corporation was organized, resulting in Floral Hall (behind the brick gate) and other buildings being erected. (Chautauqua County Fair.)

Fairs have been held every year except during World War II and in 1916. The earliest fair provided prizes for best bull, best lamb, best corn and tobacco, and best samples of cloths. Sulky races, farm exhibits, the Joey Chitwood Thrill Show, and carnival rides have entertained people for generations. (Chautauqua County Fair.)

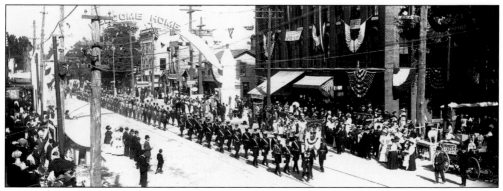

Parades were a popular form of entertainment and a chance for civic pride to be shown. Various pictures show bunting covering buildings, crowds lining the streets four and five deep, children chasing their favorite group, and people hanging out of windows and sitting on roofs. "Welcome Home" was the message for servicemen returning from action in World War I at this 1918 parade.

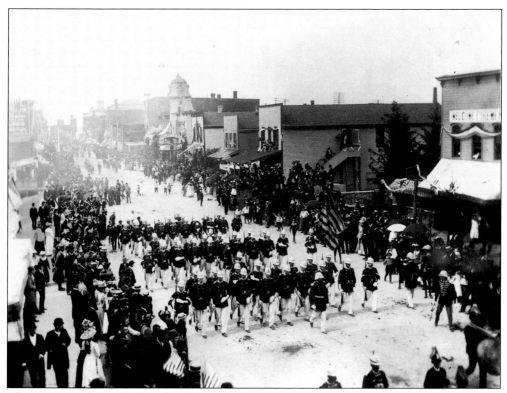

This 1892 parade on the Fourth of July celebrated the newly paved Central Avenue. Naetzker's stands at the right, the white building with circular tower is the fire hall, and in the distance on the right side of the street is the Nelson Opera House.

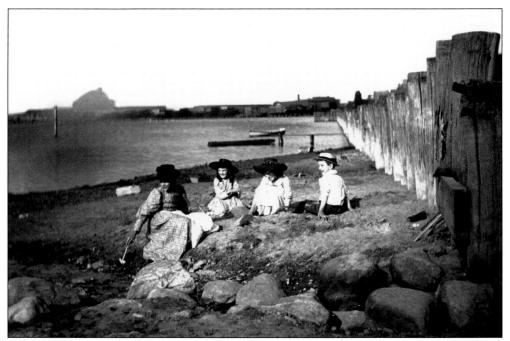

For some, leisure was found by simply walking down the street to sit by the lake. Here a family plays in the sand in 1891 along Front Street, now Lake Shore Drive. The breakwall behind them had been built to shore up erosion along Front Street, now replaced with a wall of concrete. The New York and Erie Railroad granary looms in the distance at the end of the Central Avenue public dock.

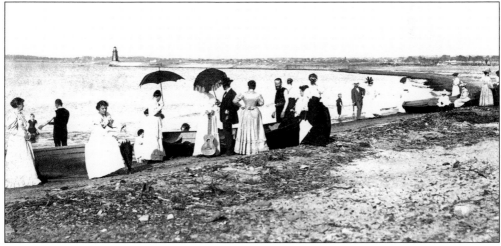

Several small summer communities sprang up along the lake's shoreline, their cooler breezes attracting out-of-towners and locals alike. Hickoryhurst was located on the bay leading to the lighthouse. Described as "a summer village of pretty cottages under the trees," the colony was named for a stand of hickory trees planted by Walter Smith. The Dunkirk Beacon sits in the distance as these properly attired people enjoy the sun in the late 1890s.

The passage of time brought different clothing styles for those who went to the beach, as evidenced by these young ladies enjoying a summer's day. Young people would be attracted to the point and to the Wright Park Beach area just as much for socializing as for swimming. (Darwin Barker Historical Museum.)

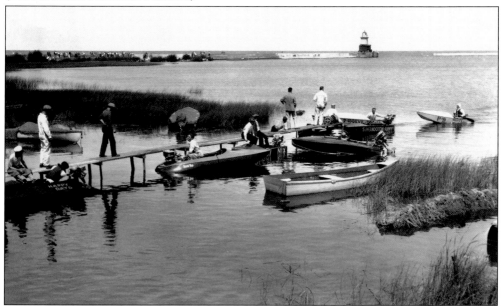

Owners of *Happy Days*, *Devil Dog*, and *Nightmare* prepare for a day of outboard motor boat racing in the lagoon at what is now the foot of Memorial Park, in 1930. The Dunkirk Racing Club operated out of the Conservation Club for a number of years putting on races. People lined the bay leading to the point and the shoreline where Memorial Park stands to feel the thrill of their speed.

Eight

RELIGION AND EDUCATION

While Dunkirk's education system developed earlier, the growth of religious denominations kept pace especially after the 1850s. In 1827, 20 years after the village's settlement, the first official school building was erected, the delay perhaps due to the shifts in population in those earliest years. Taught by teachers with no more than a "common school education"—the equivalent of today's eighth grade—school was not compulsory, and parents paid 2¢ per child for each day's attendance, the "rate bill" method of tuition.

In 1858, "union free schools" would replace that system, and a board of education would be established. In the following years, the system would evolve, a stronger trend toward more students attending high school would develop, and the range of services and specialized classes would increase.

The earliest church was the First Baptist Church, in 1830, though the congregants had no building until 1855. The First United Presbyterian Church organized later in 1830, followed by St. John the Baptist Episcopal Church, and Grace Evangelical Lutheran Church starting in the 1850s. The earliest Catholic church was that of St. Mary of the Seven Dolors, begun in 1858. Immigrants tended to settle with their own, so it was natural for churches to spring up to minister to them. The Germans eventually organized Sacred Heart parish. St. Hyacinth's and Hedwig's ministered to the Polish, while Holy Trinity served the Italians. Those churches also sought to educate the children of these immigrants for a time in their native language. The public education system would help them become more assimilated. In addition to these parish churches, a monastery operated at the Holy Cross site starting in 1920.

To this mix, members of the Jewish faith intermingled. The earliest person of Jewish faith arrived in 1864, like others hoping for acceptance and success. According to William Chazanoff's historical account of the Jewish experience in Dunkirk, "The situation in Dunkirk was a microcosm of the Jewish experience in the United States." These additions to the city would indeed become successful members of society.

Dr. Julien T. Williams practiced as a doctor but had an avid interest in his community. He started publication of city's first daily, the *Dunkirk Evening Observer*, and served as village president and president of the board of education. Historians have referred to him as the "father of the Dunkirk schools" for his valuable service. He led the system through its attempt to become the Dunkirk Union Free School District in 1858.

The 1827 two-story brick schoolhouse offered a curriculum that was elementary only. That emphasis continued, as between 1857 and 1894, 10 elementary buildings were built throughout the city. Students seated here occupied school No. 8 sometime before 1900.

Momentum for changes in the education system increased around 1900. The Compulsory Education Law was enforced by an attendance officer, and a kindergarten program started. Between 1857 and 1902, the number of teachers would rise from 8 to 56 and then to 130 in 1931.

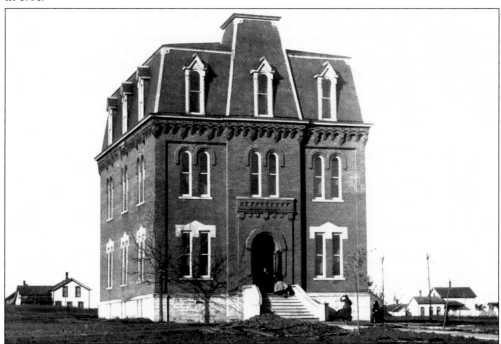

Instruction beyond the elementary level began in 1837. The Dunkirk Academy was incorporated as a private secondary institution and housed in the second story of the 1827 schoolhouse building. Other private "select" schools such as the Blackham School sprang up. Overcrowding resulted in construction of this brick building called the "Academy" in 1881 on an old burial site.

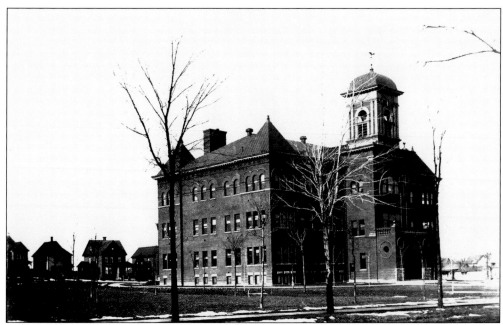

Due to increasing enrollment, an addition was made to the academy within five years of its being built and then another by 1896. The city's population would exceed 11,000 in 1900, which would propel the district toward a more modern education as more students would desire a high school education.

The bell in the academy tower serves as a symbolic connection between the working-class nature of the town and the need for education. It originated on the New York and Erie Railroad dock on Washington Avenue, where it was used to summon workers and to sound warnings. It was given to the school, ringing in the tower for the first time in 1896 and since then at class graduations and sports victories. (Photograph by Diane Andrasik.)

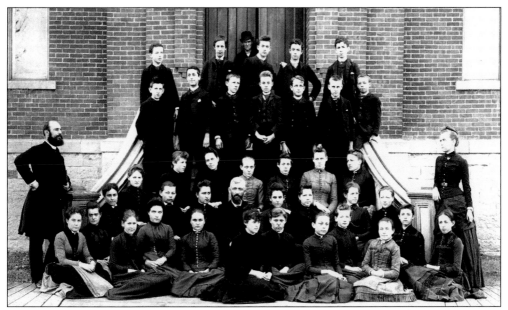

Sophomores in 1888 pose on the Dunkirk Academy's steps. Their superintendent received $1,600, the principal $1,000, and teachers $300 to $400. At the end of 1887, the total school enrollment was 1,270. In 1901, the students would choose maroon and white as their school colors. By 1905, their building would come to be called Dunkirk High School.

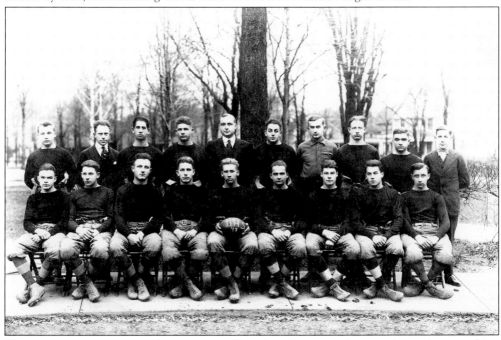

The increase in extracurricular activities allowed students to gain experiences in everything from debate and drama to dances and sports. The 1917 Dunkirk High School football team became western New York champions. Their *Citizen Annual* claimed they "had the fighting spirit" to defeat Masten Park in Dunkirk's Central Park, then Lafayette, Niagara, Edinboro, and Niagara University Reserves; Fostoria, Ohio, was the team's only defeat.

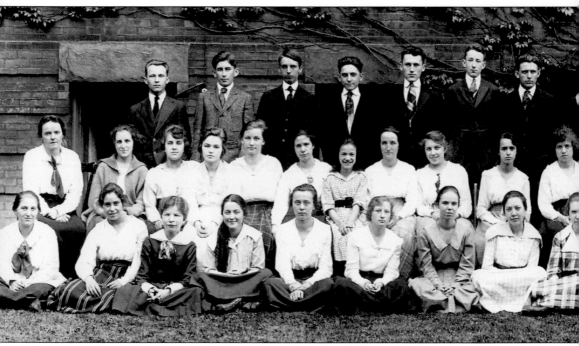

The Dunkirk High School senior class of 1919 poses for a picture that appeared in its junior-year Dunkirk High School annual in 1918. The students could take classes in science, physical education, manual training, and domestic science, all curriculum additions in the early 1900s. High school enrollment exceeded 300 with a faculty of 27 teachers. A first-year male teacher earned $900, a female $600; high school substitutes received $2.50 a day and their elementary counterparts $1.50. The 1918 seniors published the *Booster* as their yearbook. The combined

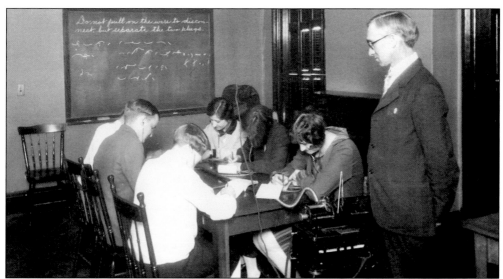

The school system prepared its students for the world of work. Here business teacher Anthony Conti oversees students in 1925 as they make use of a Thomas Edison invention called the Ediphone. The product's purpose was to record dictation for letters and notes, so a secretary could later type it by loading a cylinder in his or her machine.

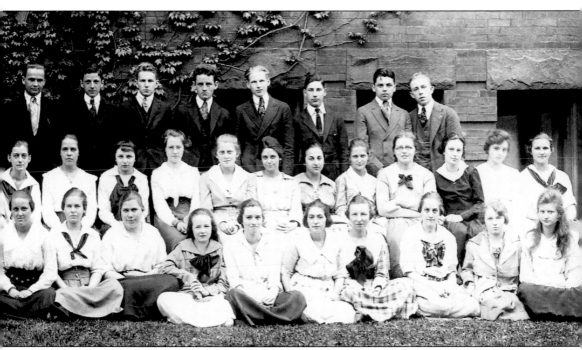

Spanish and French classes held a dance raising funds to purchase a Victrola for the school, while the Foray Club enacted *The Rivals*. The basketball team beat Fredonia 31-18; one forward named Herbert Henning, senior class president and male lead in the play, enlisted that spring. The class history finished with "Thus the war has drawn ever closer to our country and to our class."

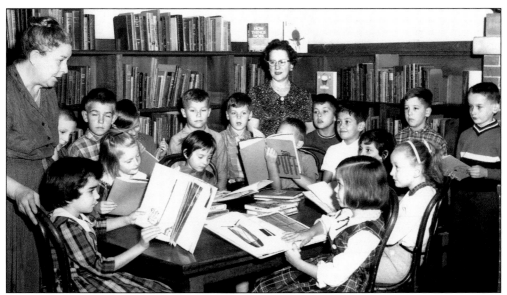

Book Week in 1961 at the Dunkirk Free Library provided another educational forum for the children of Dunkirk. Children were able to gain a love of reading from those who operated the program, here Ida Briggs Reed (left) and Louise Nowak.

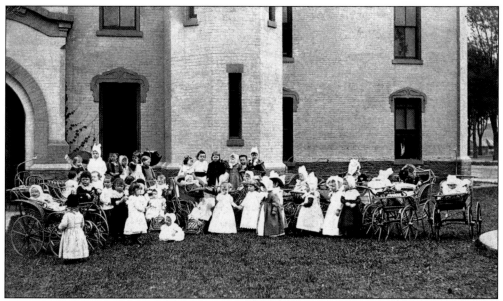

The national trend in the early 1800s was for religious orders to take responsibility for the care of orphaned children. This was the case of St. Mary's Orphan Asylum, which the Sisters of St. Joseph established in 1857. A report from 1894 notes the asylum had care of 53 children that year. Approximately 404 had been admitted to that date over the years. Note both boys and girls attired in dresses.

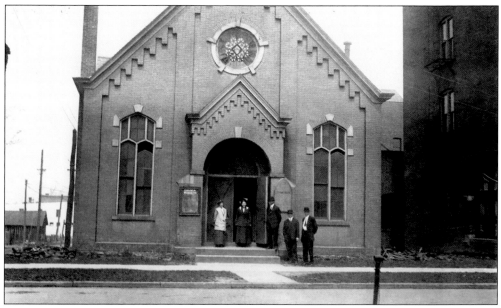

Dunkirk's first settlers brought with them various Protestant faiths. The Methodists organized in 1830, although they did not have a building until 1853. The Baptists erected their brick edifice in 1853 as well. This photograph shows St. Peter's Lutheran Church, destroyed by fire in 1918.

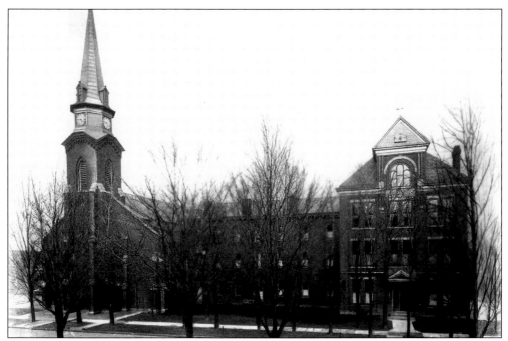

Fr. W. Lennon arrived in 1850 to organize a parish for Roman Catholics in Dunkirk, mainly the Irish and Germans. The first church was a chapel in a house dedicated to the Seven Dolors of Mary. Fr. Peter Colgan arrived and built the first St. Mary's, occupied in 1854. The parish was made up of mostly poor immigrants. Germans of that parish ultimately formed their own parish, Sacred Heart.

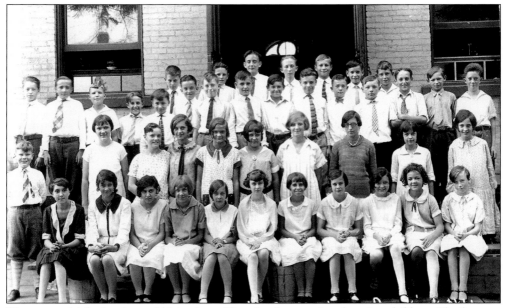

Three parochial schools would join the public school system in educating children. The first was St. Mary's, which first held classes in a basement of the church in 1860 and then a night school in 1861 for day workers. A school was finished in 1869. The seventh-grade class pictured reflects the tendency toward use of a school uniform.

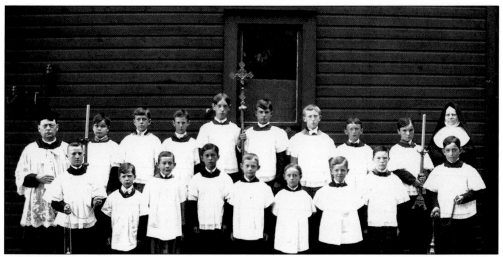

Dunkirk's German population dedicated its church to St. George in 1858, naming it Sacred Heart. The school named St. George's began in 1884. Altar boys, such as these from Sacred Heart in 1908, served a special function in the lives of their respective churches. The parish merged with that of St. Mary's to form St. Elizabeth Ann Seton Parish in 1975.

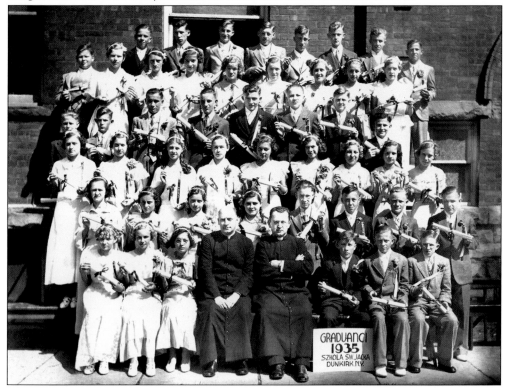

The earliest Polish immigrants arrived in Dunkirk in 1848, and 112 families helped build St. Hyacinth's in 1875. In 1967, Fr. Casimer Zak would state the parish's first 50 years had been "a haven for the immigrant." Felician sisters started its school in 1888, attaining a high enrollment of 700 in 1924–1925 when the city's population was one-third Polish. This 1935 class includes Msgr. Michael Helminiak (left), pastor for 37 years, and the author's mother.

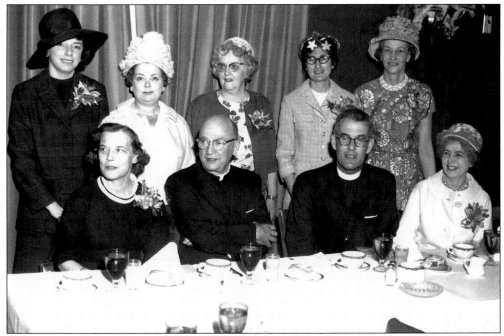

Episcopalians gathered to worship in the city as early as 1823, organizing a parish in 1850, St. John the Baptist. They held services in their first church on Central Avenue and then built the present one in 1867. Fr. Leslie F. Chard served as rector from 1928 to 1966 and also as city historian. He sits, second from the left, at a women's breakfast in the 1950s. (St. John's Episcopal Church.)

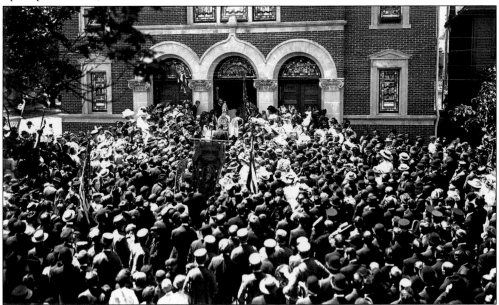

Italians arrived in Dunkirk by 1888, formed their own parish, Holy Trinity, in 1908, and built their church the next year. Fr. Valerio Bernado, pastor for 29 years, would inspire the building of a new edifice on Central Avenue. Dunkirk's Italians joined organizations such as the Victor Emmanuel Society, Amity Club, and Messina Club in their efforts to retain cultural identity.

Begun as a Catholic high school for boys in 1950 and named after the primate of Hungary, Cardinal Mindszenty High School started with 40 students in the Gross mansion on Central Avenue. Its new building opened the following year, and the school went coed but closed in 1979. Here the M Club of 1957 stands.

Immigrants of Jewish faith arrived in the 1860s, not establishing a formal place of worship until 1914, when 16 members of the community voted to create the Hebrew Community of Dunkirk. They worshiped in the Dunkirk Cycle Club first and then built a new temple on Washington Avenue. In 1941, members of Temple Beth El celebrated payment of their mortgage. Their successful integration within the community was evident when Myer Einstein was elected mayor in 1907. (Temple Beth El.)

Nine

NATIONAL CONNECTIONS

People and events of national and historic importance have touched Dunkirk throughout the city's 200-year existence. The Marquis de Lafayette disembarked at the harbor in 1825 on his tour of America; Italian patriot and soldier Giuseppe Garibaldi visited in 1850, interested in local candle-making methods. The city's designation as terminus of a major railway line thrust it into national prominence, bringing Pres. Millard Fillmore and other dignitaries of national prominence to Dunkirk. Other national candidates for office arrived in the city to stump from the back of trains. Adlai Stevenson did so on his run for president, and Franklin Roosevelt visited as well.

Issues revolving around the Civil War swept through Dunkirk. Escaped slaves traveled through the city on their Underground Railroad route. On February 16, 1861, Pres. Abraham Lincoln stopped in Dunkirk as he traveled to his inauguration. Speaking from the rear platform of his train, he asked, "Standing here beneath the flag of our country, will you stand by me as I stand by that flag?" Over 1,000 Dunkirk men answered that Dunkirk would indeed stand by him and depart by train to fight for the Union. Three years later, on April 28, 1865, the train carrying the body of Lincoln would stop at the same station at midnight, bearing him back for burial after his assassination.

Other wars followed, and in World Wars I and II and the conflicts that followed, Dunkirk men and women would serve. World War I– and World War II–era photographs reveal large multitudes crowding the union depot, awaiting the departure of troops by train. The names of men who died in World War II read like a melting pot of immigrants whose ancestors worked on the railroad and the Brooks Locomotive Works, at Allegheny Ludlum Steel Corporation, and in the shops along Central Avenue: Frank Acquavia, Caspar Zacharias, James Connaly, Robert Dotterweich, Frank Kozlowski, and Charles Tinley, principal of the Dunkirk Industrial High.

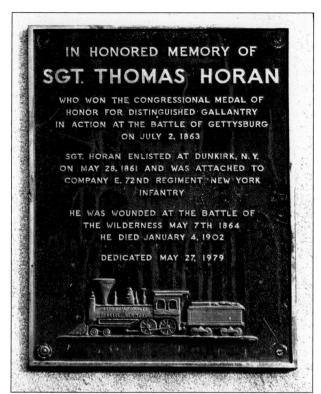

IN HONORED MEMORY OF

SGT. THOMAS HORAN

WHO WON THE CONGRESSIONAL MEDAL OF
HONOR FOR DISTINGUISHED GALLANTRY
IN ACTION AT THE BATTLE OF GETTYSBURG
ON JULY 2, 1863

SGT. HORAN ENLISTED AT DUNKIRK, N.Y.
ON MAY 28, 1861 AND WAS ATTACHED TO
COMPANY E, 72ND REGIMENT, NEW YORK
INFANTRY

HE WAS WOUNDED AT THE BATTLE OF
THE WILDERNESS MAY 7TH 1864
HE DIED JANUARY 4, 1902

DEDICATED MAY 27, 1979

Sgt. Thomas Horan was Dunkirk's Medal of Honor winner, memorialized by a plaque attached to the back of the city's Civil War monument that now stands in Washington Park. Enlisted in Company E of the 72nd Regiment, he was cited for capturing the flag of the 8th Florida Regiment. (Photograph by Diane Andrasik.)

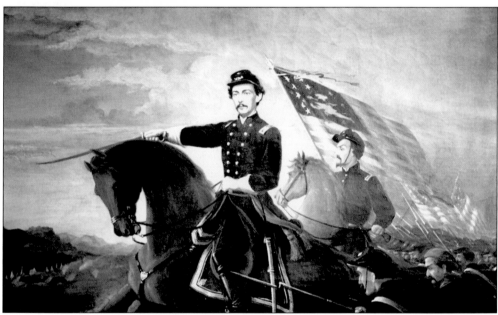

The Civil War involved Chautauqua County's 68th Infantry. Dunkirk contributed three companies of the 72nd Regiment, New York Volunteer Infantry. W. O. Stevens, a Harvard graduate, lawyer, and district attorney of Chautauqua County, was made captain of Company D. Promoted to major and then colonel, he was given command of the regiment. He was killed in the battle of Chancellorsville. (McClurg Museum.)

Daniel A. Reed became a law partner in a Dunkirk firm, coached Dunkirk High School football, and served as president of the Young Men's Association. A Republican, he was representative of the 43rd Congressional District from 1919 to 1959. *Dunkirk Evening Observer* editor Walter Brennan said he was "a splendid example of the sincerity, the decency, the courage and the intellect we have the right to expect of all men in public life." (Courtesy of the Archives and Special Collections, State University of New York, Fredonia.)

Dunkirk experienced World War II when some 400 German and Italian prisoners of war were housed in the 4-H building at the fairgrounds and used to ease the labor shortage in nearby food-processing plants. Those pictured here are being directed by their own "spokesman"—a former innkeeper and member of the Rommel's Afrika Corps. A U.S. Army guard of Jewish faith served as interpreter. (Darwin Barker Historical Museum.)

In 1973, Peter Toth, whose family escaped from Hungary just as the Communists were taking over, chose Dunkirk as one of the 50 cities in which to create a sculpture to "bring into focus . . . the plight of this nation's original citizens." The Dunkirk sculpture is named *Ong-Gwe-Ohn-Weh*, meaning "the Indian." In return, Toth was given the Native American name the Wolf. (Photograph by Diane Andrasik.)

Frank Acquavia was captured in the fall of Corregidor in the Philippines and held prisoner of war, until he was killed by a Japanese sentry in May 1942. He was awarded the Purple Heart and Bronze Star defense ribbons for his service. The Frank Acquavia Memorial Post 1344 American Legion was named in his honor. (Frank Acquavia Memorial Post 1344, American Legion.)

BIBLIOGRAPHY

Bush, Gladys A. "Dunkirk: A Chronology and Index of Historical Facts, 1626–1946." Dunkirk Historical Museum.

Chard, Leslie F. *Out of the Wilderness*. Dunkirk, NY: McClenathan Printery, 1971.

Chazanof, William. *A Legacy of Faith: The Jews of the Dunkirk-Fredonia Area*. North Liberty, IA: Ice Cube Press, 2000.

Chewning, J. A. *Dunkirk, New York: Its Architecture and Urban Development*. Dunkirk, NY: Access to the Arts, 1992.

Commercial Association of Dunkirk. *Historical and Descriptive Review of Dunkirk*. Dunkirk, NY: Commercial Association of Dunkirk, 1880.

Doty, William J., ed. *The Historic Annals of Southwestern New York*. Vols. I and II. New York: Lewis Historical Publishing Company, 1940.

Downs, John P., ed. *History of Chautauqua County and Its People*. Vols. I, II, and III. New York: American Historical Society, 1921.

Edson, Obed. *History of Chautauqua County, New York*. Boston: W. A. Fergusson and Company, 1894.

Gordon, William R. *Buffalo and Lake Erie Traction Company*. Albion, NY: Eddy Printing, 1977.

Leet, Ernest D., ed. *History of Chautauqua County, New York, 1938–1978*. Westfield, NY: Chautauqua County Historical Society, 1980.

Severance, Henry. *Chautauqua*. Buffalo, NY: Art-Printing Works of Matthews, Northrup and Company, 1891.

Shepard, Douglas H. *The Packet Seed Companies of Fredonia, New York, 1834–1988*. Fredonia, NY: Arkwright Printing Company, 2002.

St. Hyacinth Church. Hackensack, NJ: Custombook, 1975.

Steinbrenner, Richard T. *The American Locomotive Company: A Centennial Remembrance*. Warren, NJ: On Track Publishers, 2003.

Young, Andrew W. *History of Chautauqua County, New York*. Buffalo, NY: Matthews and Warren, 1875.

DISCOVER THOUSANDS OF LOCAL HISTORY BOOKS FEATURING MILLIONS OF VINTAGE IMAGES

Arcadia Publishing, the leading local history publisher in the United States, is committed to making history accessible and meaningful through publishing books that celebrate and preserve the heritage of America's people and places.

Find more books like this at
www.arcadiapublishing.com

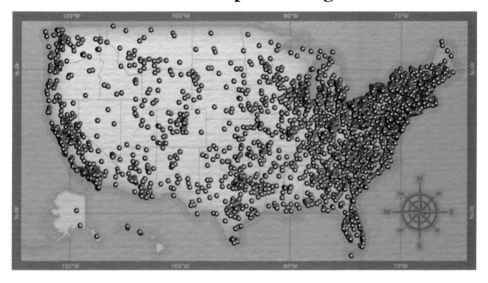

Search for your hometown history, your old stomping grounds, and even your favorite sports team.

Consistent with our mission to preserve history on a local level, this book was printed in South Carolina on American-made paper and manufactured entirely in the United States. Products carrying the accredited Forest Stewardship Council (FSC) label are printed on 100 percent FSC-certified paper.

MADE IN THE USA